Framed Memories

A CENTURY
OF STORIES
NEW HANOVER COUNTY PUBLIC LIBRARY
1906-2006

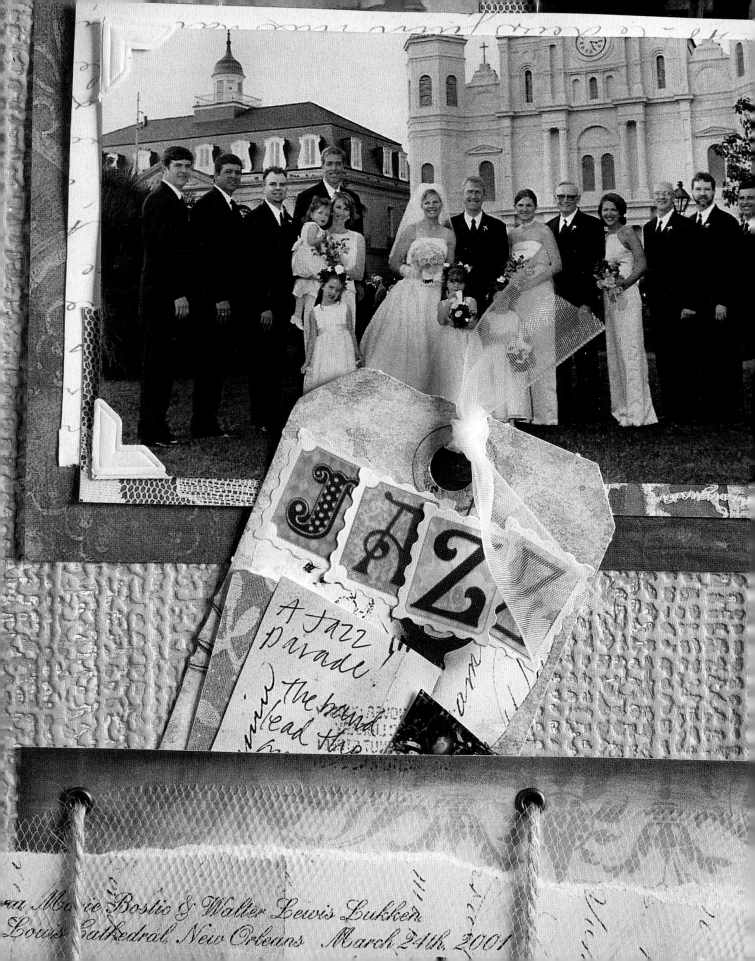

JAZZ

A Jazz
Parade!

the band
lead the

Marie Bostic & Walter Lewis Lukken
Louis Cathedral, New Orleans March 24th, 2001

Framed Memories

Creative Scrapbooking Projects for Your Home

Stephanie Inman

LARK BOOKS

A Division of
Sterling Publishing Co., Inc.
New York

Library of Congress Cataloging-in-Publication Data

Inman, Stephanie.
 Framed memories : creative scrapbooking projects for your home / by
Stephanie Inman.-- 1st ed.
 p. cm.
 Includes index.
 ISBN 1-57990-682-6 (pbk.)
 1. Photographs--Conservation and restoration. 2. Picture frames and
framing. 3. Scrapbooks. I. Title.
TR465.I68 2006
745.593--dc22
 2005024116

EDITOR: Joanne O'Sullivan

ART DIRECTOR: Kristi Pfeffer

COVER DESIGNER: Barbara Zaretsky

ASSOCIATE ART DIRECTOR: Shannon Yokeley

ASSOCIATE EDITOR: Susan Kieffer

ART PRODUCTION ASSISTANT: Ardyce E. Alspach

EDITORIAL ASSISTANCE: Delores Gosnell

PHOTOGRAPHY: Martin Fox Photography
 (Martin Fox and Sallye Fox)

10 9 8 7 6 5 4 3 2 1

First Edition

Published by Lark Books, A Division of
Sterling Publishing Co., Inc.
387 Park Avenue South, New York, N.Y. 10016

Text and illustrations © 2006, Stephanie Inman
Photography © 2006, Lark Books

Distributed in Canada by Sterling Publishing,
c/o Canadian Manda Group, 165 Dufferin Street
Toronto, Ontario, Canada M6K 3H6

Distributed in the United Kingdom by GMC Distribution Services,
Castle Place, 166 High Street, Lewes, East Sussex, England BN7 1XU

Distributed in Australia by Capricorn Link (Australia) Pty Ltd.,
P.O. Box 704, Windsor, NSW 2756 Australia

If you have questions or comments about this book, please contact:
Lark Books
67 Broadway
Asheville, NC 28801
(828) 253-0467

Manufactured in China

ISBN 13: 978-1-57990-682-5
ISBN 10: 1-57990-682-6

For information about custom editions, special sales, premium and corporate purchases,
please contact Sterling Special Sales Department at 800-805-5489 or
specialsales@sterlingpub.com.

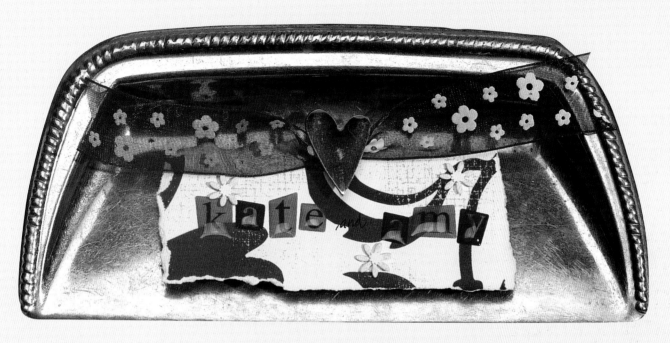

Dedicated to Kate and Amy

Contents

Getting Started *page 10*

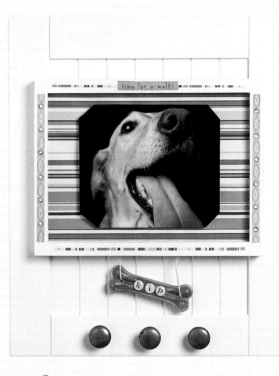

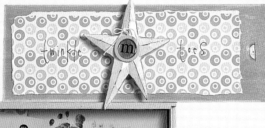

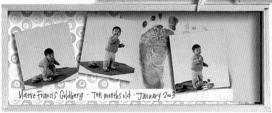

Milestones *page 21*

Friends and Family *page 33*

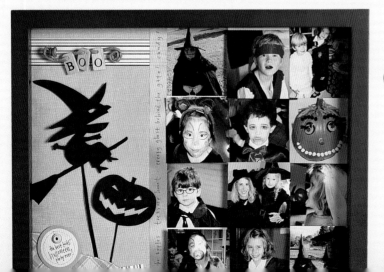

Celebrations *page 57*

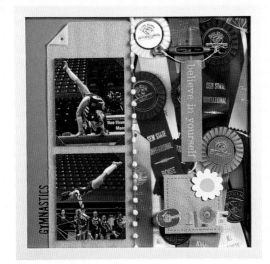

Do
What You Love *page 77*

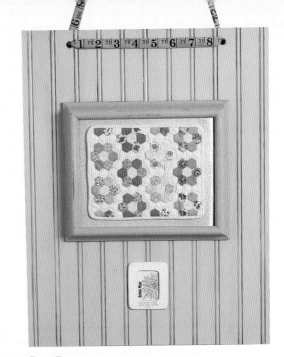

Nostalgia *page 102*

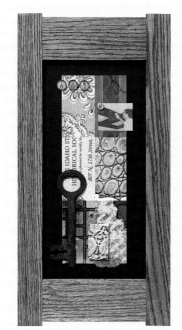

No Place
Like Home *page 92*

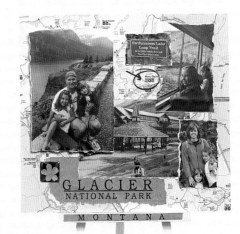

Destinations *page 113*

Introduction

Your favorite photos, mementos, and keepsakes, artfully arranged in a scrapbook: they are a celebration of your life and your experiences. So why hide them away? Turn your layouts into meaningful gifts or works of art that are functional or simply beautiful to look at by moving them out of the scrapbook and into the spotlight. A framed memory—displayed on the wall or even on a desktop—lets you combine your love of scrapbooking with your eye for interior design. Your memory pieces become not only personal keepsakes, but decorative accents that enhance your home.

Framed Memories is a source book for self-expression that's designed to take you in new creative directions. You already know the basics of scrapbooking, from setting an eyelet to decoupaging a photo. You're comfortable with a printer and a scanner. You use acid-free papers and products and photocopies instead of originals. But I think this book will introduce you to new design concepts and materials that will give you more creative freedom. I'll provide some tips for making the most out of the materials you've got and give you some pointers on creating designs that succeed "off the page" and in the context of your home.

I've created more than 40 projects and included lots more variations to spark your imagination. From displays celebrating life's milestone moments to artful arrangements of your family vacation photos, you'll find ideas that are easy to adapt to your own unique celebrations.

For a housewarming present, surprise friends or family with a framed design showcasing their home. Delight new parents with a sweet nursery display featuring baby photos and their birth announcement. Thank a coach with a creative shadow box that holds the team photo and the players' signatures and best wishes. These projects are not only fun to make, but are sure to be cherished by their recipients.

Of course there's nothing wrong with saving some of your best ideas for your own home. It's fun to make memory pieces that serve a purpose: a dog-leash holder featuring a photo of your favorite mutt, or a tie hanger for dad enhanced with a family photo. You can also design a piece for a specific room of your home: use a pizza pan as a frame for a funky kitchen display, or an old garden rake head as the foundation of an outdoor ornament.

Whether your style is modern, traditional, funky, classic, or retro, you'll find examples that you can use—there is truly something for everyone. I use some traditional scrapbooking techniques and supplies in my work, but I love throwing in an unexpected twist to create a really fresh design: a surprising element—a wooden skewer or piece of bike chain; a found object frame, such as a piece of beadboard or a basket; or an unusual way of displaying a piece—maybe in a tray or on an easel. Because these projects aren't confined to the page of a scrapbook, there are no rules. Your projects can be simple and sophisticated or witty and vibrant. It's all up to you.

I hope you'll find inspiration in these pages. It's my wish that you'll have a lot of fun sharing your stories and creating your very own framed memories.

Go creative spirit go!

Stephanie

Stephanie Inman

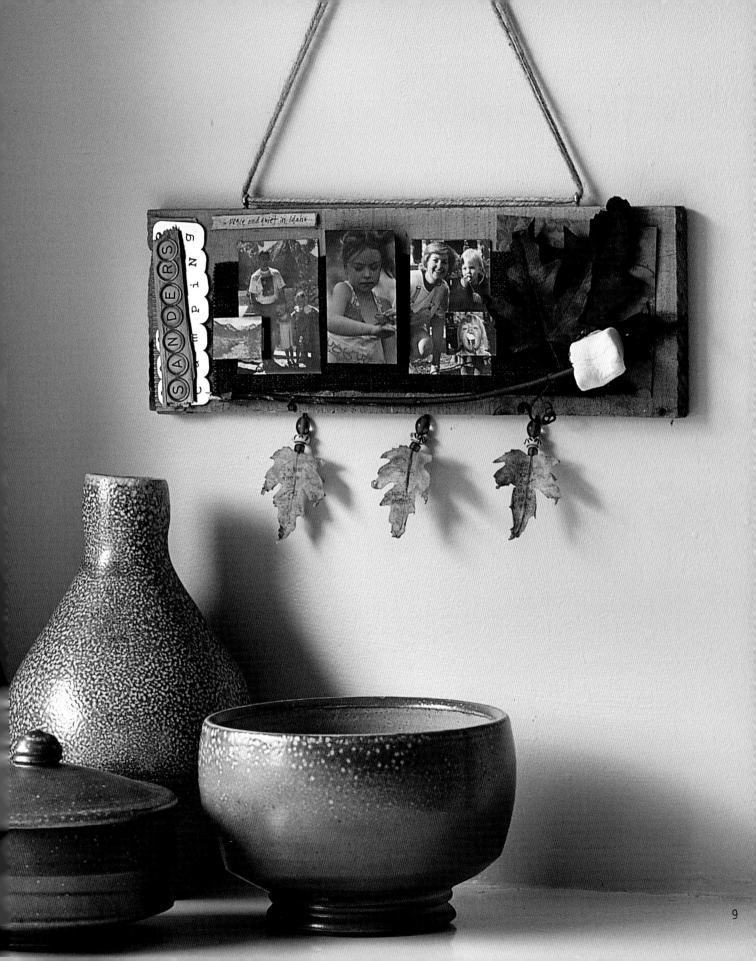

Getting Started

What's Your Story?

Every framed memory tells a story. So what story do you want to tell? The answer to that question is at the heart of every inspired framed memory project.

At the beginning of your creative process, clarify your purpose for the project and narrow down your focus. If for example, you went to Hawaii on your honeymoon, try to capture just the essence of the trip and evoke the feeling and mood of your memories. You don't have to include every snapshot you took on the beach—a framed memory isn't a play-by-play. Instead choose the one or two images that best capture the spirit of your trip and make them the key elements of your piece.

For every project, ask yourself what is unique about the person, subject, or experience featured in your project and try to reflect those distinctions in your layout. With a clear intention in mind stay on track and focus your creativity.

Hunting and Gathering

Before I start a new design, whether it's a home remodeling display or a gift piece highlighting a baby's first steps, I gather all the information I have—photos, tidbits, journaling, emails from the subject, etc. Then I brainstorm layouts and how the piece could be displayed.

Collecting ideas is just as important as collecting materials. Layout ideas come from everywhere. Sometimes I see a label I love, and it inspires me to use a certain color or run type along one edge. Or I get ideas from the way a photo is treated on a website, or the way green fades to blue on a business card or the graphic packaging my new cell phone came in. Great design is everywhere.

After deciding on the subject matter, the frame, and, possibly inspired by a layout idea, I sketch. I do a rough layout first, noting where I plan to put different items. Ribbon here. Paint color there.

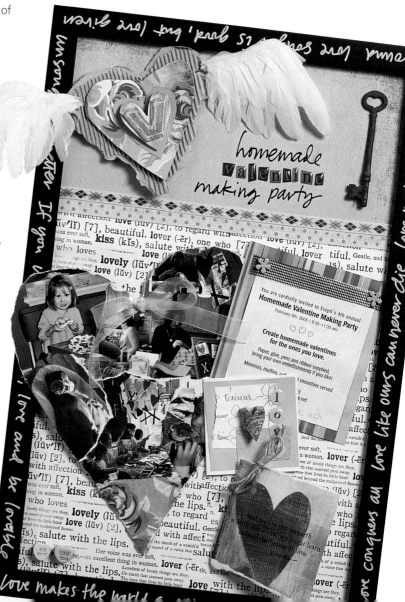

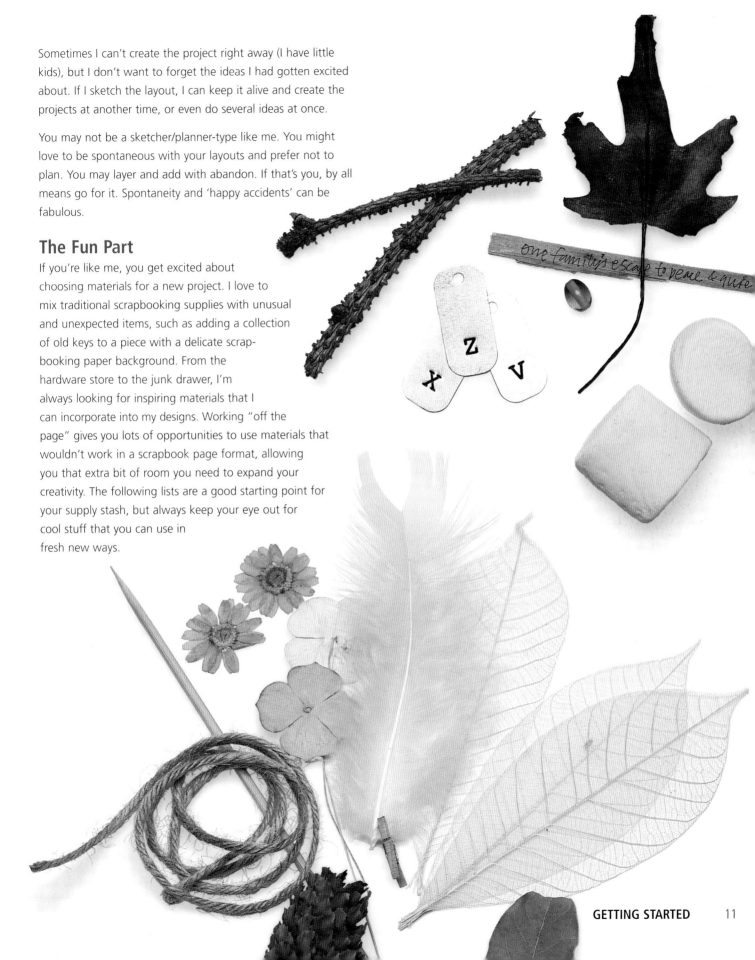

Sometimes I can't create the project right away (I have little kids), but I don't want to forget the ideas I had gotten excited about. If I sketch the layout, I can keep it alive and create the projects at another time, or even do several ideas at once.

You may not be a sketcher/planner-type like me. You might love to be spontaneous with your layouts and prefer not to plan. You may layer and add with abandon. If that's you, by all means go for it. Spontaneity and 'happy accidents' can be fabulous.

The Fun Part

If you're like me, you get excited about choosing materials for a new project. I love to mix traditional scrapbooking supplies with unusual and unexpected items, such as adding a collection of old keys to a piece with a delicate scrap-booking paper background. From the hardware store to the junk drawer, I'm always looking for inspiring materials that I can incorporate into my designs. Working "off the page" gives you lots of opportunities to use materials that wouldn't work in a scrapbook page format, allowing you that extra bit of room you need to expand your creativity. The following lists are a good starting point for your supply stash, but always keep your eye out for cool stuff that you can use in fresh new ways.

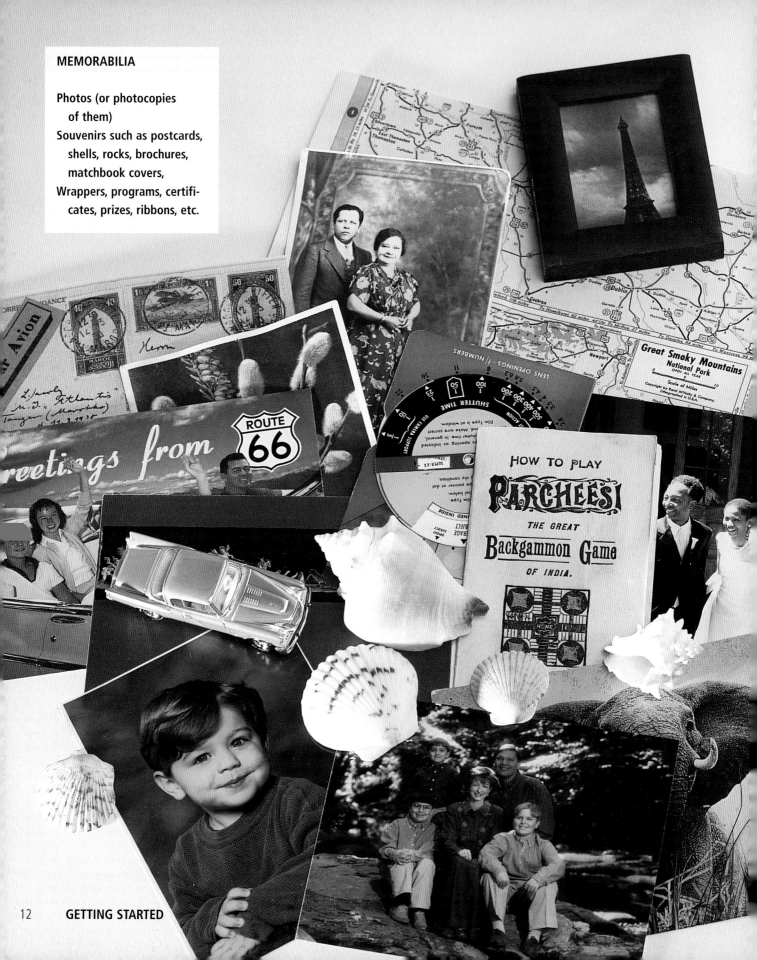

MEMORABILIA

Photos (or photocopies
 of them)
Souvenirs such as postcards,
 shells, rocks, brochures,
 matchbook covers,
Wrappers, programs, certifi-
 cates, prizes, ribbons, etc.

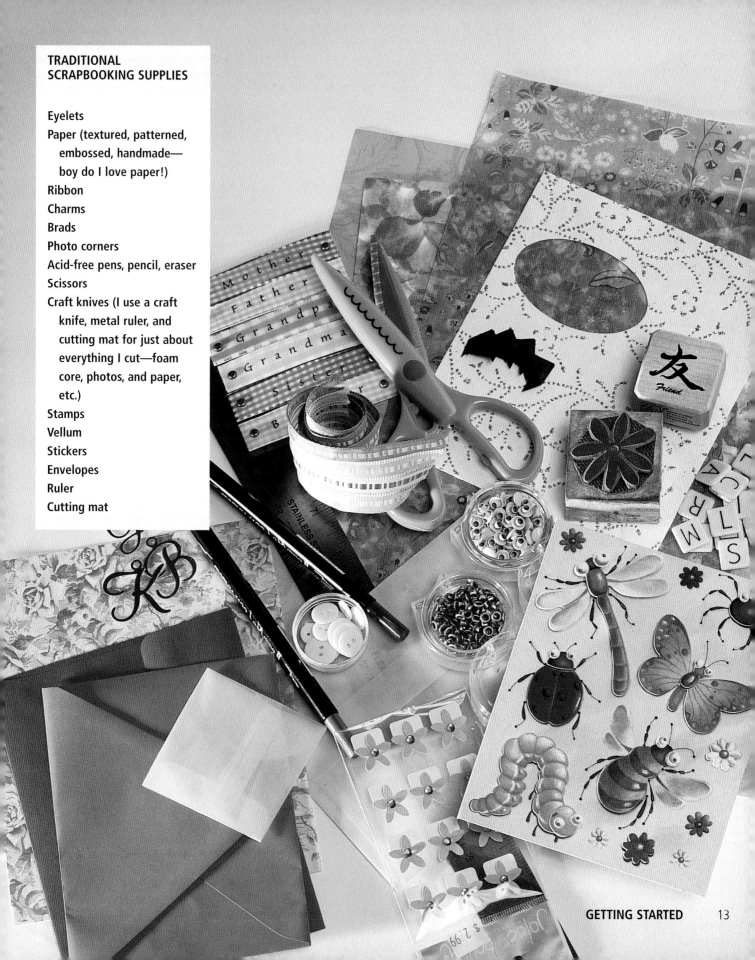

TRADITIONAL SCRAPBOOKING SUPPLIES

Eyelets

Paper (textured, patterned, embossed, handmade—boy do I love paper!)

Ribbon

Charms

Brads

Photo corners

Acid-free pens, pencil, eraser

Scissors

Craft knives (I use a craft knife, metal ruler, and cutting mat for just about everything I cut—foam core, photos, and paper, etc.)

Stamps

Vellum

Stickers

Envelopes

Ruler

Cutting mat

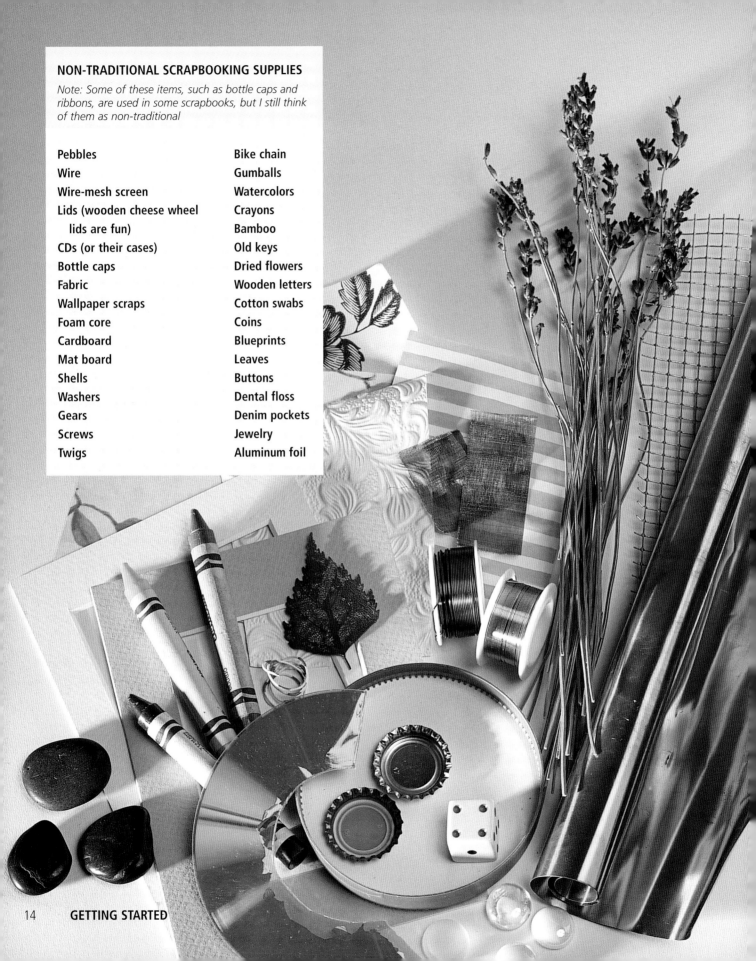

NON-TRADITIONAL SCRAPBOOKING SUPPLIES

Note: Some of these items, such as bottle caps and ribbons, are used in some scrapbooks, but I still think of them as non-traditional

Pebbles

Wire

Wire-mesh screen

Lids (wooden cheese wheel lids are fun)

CDs (or their cases)

Bottle caps

Fabric

Wallpaper scraps

Foam core

Cardboard

Mat board

Shells

Washers

Gears

Screws

Twigs

Bike chain

Gumballs

Watercolors

Crayons

Bamboo

Old keys

Dried flowers

Wooden letters

Cotton swabs

Coins

Blueprints

Leaves

Buttons

Dental floss

Denim pockets

Jewelry

Aluminum foil

A Note on Paper

Consider non-traditional sources for paper: greeting cards, gift bags, or wallpaper. You can even try working on top of artwork you're tired of! See if you can get a hold of a paper sample book (a collection of paper swatches paper companies create for marketing purposes)—many graphic designers and commercial printers will give you old ones that they're not using any more for free. The papers in sample books are often small (around 6 x 9 inches (15.2 x 22.9 cm)), but they're very cleverly packaged and often come in interesting colors and textures you won't always find in paper stores open to the public.

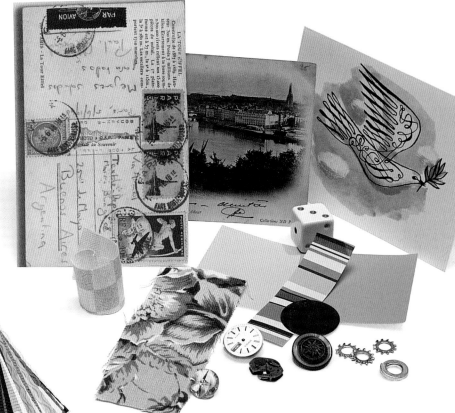

Left: Paper sample books, available from commercial printers, give you lots of variety from one source. **Above:** Greeting cards, postcards, and wallpaper scraps are also interesting alternatives to scrapbooking paper.

Holding It All Together

You need strong adhesives when creating framed memories. I love to work with industrial adhesive. It dries overnight and can hold just about anything—even a plate to a heavy piece of cardboard—so it gives you a lot of freedom with a variety of elements. Scrapbooking products like adhesive dots or tape can work on some light paper items, but in general I prefer to spray mount lighter items onto card stock and then adhere them to a background using stronger, more permanent adhesives. I try and make everything really stick on there the first time.

ADHESIVES	OTHER "CONNECTERS"
Glue	Wire
Industrial adhesive	Eyelets
Spray adhesive	Staples
Packaging tape	Grommets
Glue dots	Twist ties
Decoupage medium	Cording, twine or
Double stick tape	heavy ribbon
Foam core squares	

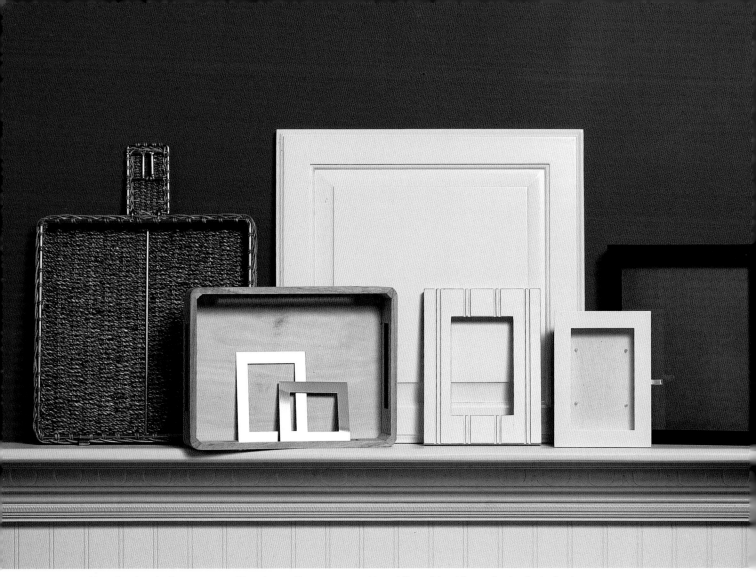

Unexpected items, such as baskets, trays, or cabinet doors, offer new opportunities, while traditional frames let the display be the star.

Framing

Normally you will want the subject to be the focus, and not the frame. Consider how you want the frame to complement the subject, and the framed display to complement your room. Or, you may want the project to contrast with the surroundings so that it becomes a focal point. It all depends on your goal for the display.

There are lots of framing options available for different types of projects: shadow boxes, traditional frames, wooden boxes, or picnic baskets are just a few choices available to you.

Traditional frames are available everywhere of course, but you may not even need to shop for one. Don't forget about frames you already have—it's fun to adapt something tired

with paint, fabric, decoupaged paper, beads, or even your own handwriting. I also like to check out antique stores and garage sales for frames or other ways to display items.

You can purchase pre-made shadow boxes, or make your own by adding a deep back kit to an existing frame. A frame shop can also do this for you.

One of my favorite ways to make a framed memory, though, is to use a simple frame without the glass. Elements pop off the background and you can see and feel the textures. Because I am usually working with photocopies, the projects aren't often as precious as the originals you'd want protected under a mat and glass.

NON-TRADITIONAL FRAME IDEAS

Pizza plate

Hatbox

Wooden crate

Wire bin

Rusty old gate

Mini ironing board

Old computer monitor

Rice paper banner

Large piece of driftwood

Tray (wood, silver or
plastic)

Bamboo or plastic
placemat

Lampshade or old rake
end (make a mobile)

Tote bag or T-shirt

Cabinet door

Artist canvas

Hats

Frame within a frame

Customizing Frames

Choose a method that meshes with the feel of the design—gold leaf would be great for a more formal design, for example, while handwriting on a frame can look casual, elegant, or artistic.

OTHER WAYS TO ALTER FRAMES

Staining

Painting (don't forget
crackle paint and other
paint techniques like
striping and stamping)

Gold leaf

Etching glass

Write on the frame

Decoupage (drawings,
photos, illustrations,
newspapers)

Additions (add bamboo,
pinecones, flowers, etc.
along edges of frames
or grouped in a corner)

Using a Mat

A mat is traditionally used to enhance and protect a project—it keeps original art from touching the glass and prevents color loss and paper buckling. But I almost always use mats solely for decoration in this book, and often with no glass at all (as I'm working with copies of originals). I use mats for visual interest—a resting spot for the eye or an opportunity to draw out a certain color in the layout. I prefer really chunky thick mats. Puny ones—why bother? You can use a mat to create a border in a layout. A fun way to do this is to make what I call a reverse mat—the center image is raised and the border is a flat background.

Design Essentials

Design freedom—it's what I love about working with dimensional displays off the scrapbooking page. You're not limited to a specific size, thickness, material, or format. You can go beyond 2-D and use 3-dimensional items. You don't have to worry what the back will look like. Oh, the glorious freedom! Now you can use a frame within a frame, a dried corsage, or that cherished necklace in a project. You can add height and give importance to specific items too (see the Display Tips section for more info). You'll find it refreshing and very creative to work with this no-rules approach. To move your creativity along, let's go over some helpful design principles: composition, dimension and layering, scale, and context.

Composition

Strong composition can be a hard thing to define but here are some points to consider:

Focal point. Always create a focal point to draw the viewer's eye. Other elements in your display, such as the ribbon in the background or an object tilting at an angle, can lead the eye toward the focus.

The focus doesn't have to be in the center—an asymmetrical layout can be more dynamic. Change your orientation from horizontal to vertical. Look at the back or bottom of an item (a basket or gift bag, for example) for an interesting alternative.

Number of elements in the display. An odd rather than even number of elements is the most pleasing. I especially love groupings of three or five.

Spacing. Placing objects so that they are barely touching looks rather timid. Instead, intentionally overlap elements or keep them deliberately apart for a stronger layout.

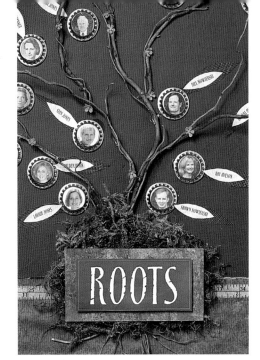

A single word in a strong typeface creates a focal point for this piece.

Unity. Do the items belong together or do they just look like separate bits stuck on? Each element should have a visual connection to the others. Create unity with overall color (warm or cold) or with elements that bring objects together (such as a consistent circular shape for the photos, for example).

Proximity. Items relating to each other should be grouped closely together to create a visual unit.

White space. Resist filling in every little bit inside the frame. White space is your friend. If you can't help but cram it full, let the eye rest with a thick mat or frame.

Perspective. Your photos don't all have to be shot straight on. Use photos taken from different angles—to the side, above, or below.

Break out. Let some items break out of the boundary— a souvenir over the mat, items applied to the frame's edge, oversized letters layered on a photo.

The numbers on this display are grouped in threes for a strong composition.

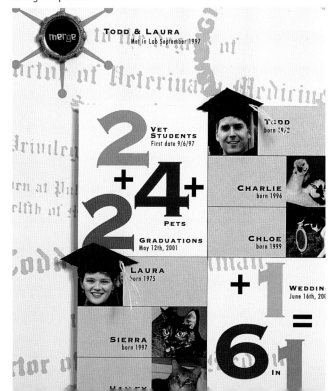

Create a layered look without the clutter by using foam core or cardboard under a photo or other element.

Fonts. If you use two fonts together, make sure they contrast. A very bold typeface pairs nicely with a very light typeface. I like to use a serif and a san-serif together. Don't fill corners with angled type.

There are two additional font tips I think are essential. First, never use a script font in all caps. Second, be careful about kerning. Kerning relates to letter spacing. Many fonts have too much room between a first cap letter and the lower case following letters. This is a big no-no in graphic design. It gives away amateurs in brochures and billboards every day. Always bring your letters together with even spacing (whether on the computer or with stamps or stickers or your own handwriting) and all of your work will look more professional and polished.

Dimension and Layering

One of the great advantages a framed memory has over a scrapbook page is the opportunity for greater dimension. Adding a bit of dimension gives a project more interest and focal elements more prominence. It also creates great shadow lines. I like to spray mount photos and text weight paper to card stock or mat board and build up a backing with a few layers of foam core below. You can create this depth by layering heavy boards (such as foam core) with industrial adhesive or by punching holes and threading wire through the whole stack.

Scale

When you think about scale, there are actually two aspects to consider—the scale of the arrangement within the frame, and the frame (or a grouping of frames) in the overall room. A project framed for your wall is generally made on a larger

scale than a scrapbook page layout. Also remember that wall displays are viewed from a distance, whereas scrapbook page layouts are viewed close-up (directly above the page in a scrapbook). A wall piece allows you to display your project as a work of art.

Decide how you'd like the framed project to work in a room. Framed memory pieces can be bold focal points or recede into a monochromatic background. Use cues from your decorating—specific fabrics, trims, paint, finishes, and accessories.

Context

Think about your options for displaying your project: tabletop stands and easels, under a glass tabletop, in a tray. A wall project can be hung with metal robe hooks, huge rusty nails and a long ribbon, wooden pegs, or curtain rods. Your display is another opportunity to tie in to your theme or style. A fish-shaped cabinet knob can be adapted to hold a fishing-line-hung display that focuses on fishing at a vacation cabin. A tote embellished with iron-on baby photos can hang from a nail covered by a little footprint impression.

Placing this arrangement on an easel makes it special, like a piece of artwork.

Clothespins on a taut string can hold the black and white photos of your dear cat sleeping in the laundry basket. Gallery shelves (or ledges) are a great place to prop up frames and projects, and can be a great alternative to a "molly bolt in the wall commitment." Let your project inform your choices about placement of a piece and incorporate the environment into your design. When both aspects are considered, the finished product has a very striking and unified appearance.

A Note on Framing Valuables

If you're going to be displaying valuables as part of your project, you've got to take extra precautions. Use an archival mat and backing materials, and UV-protective glass. Never display the project in direct sunlight, or let it hang them over a heat source or in any high humidity areas. Applying felt circles to the backs of your frames will also allow air to circulate to further prevent any damage.

Getting Over Creative Block

Now you've got a good grasp on design, but what if you're still creatively stuck? If you're having trouble with a project, my advice is to think of what you would normally do, then do the opposite. It sounds like something George Costanza from *Seinfeld* would say, but it can work if you're not happy with your project and need to expand your options. For example, if you were going to paint a project background purple, think about the opposite, like using a row of orange CD cases instead. If you were planning to use a shiny new ornament in a display, consider using a rusty old gear or hanging a dried gourd you can write on, or wood burn instead. Add a little contrast to your projects in ways that emphasize your focus. When framing a shiny new award ribbon, think about making the background a monotone—say, a canvas of crumpled craft paper (and not a bright color that could compete with your focus). The crumpled craft paper is a different texture than the ribbon, emphasizing the ribbon's smooth lines, and the color contrast emphasizes the ribbon again. It could also make for some interesting shadow lines. I love the contrast of combining old and new, bright and dull, smooth and rough texture.

One final tip

Throw out the rules if you like. These projects are intensely personal and subjective. Create what pleases you.

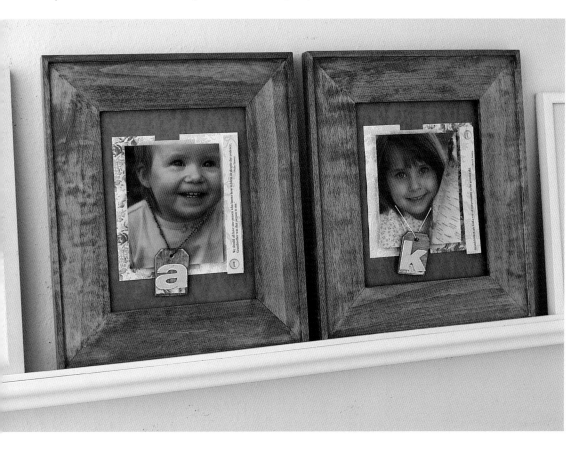

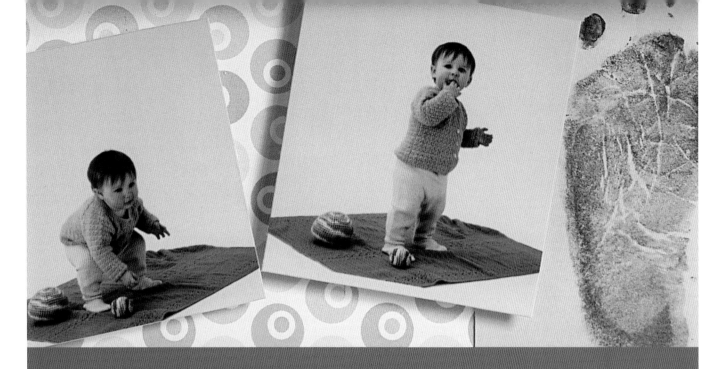

Milestones

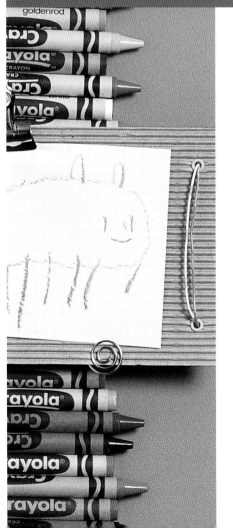

First steps, first drawings, first days of school. These are memories that you'll want to preserve in a meaningful display. A beautiful birth announcement can become the anchor of a colorful display with pictures from a baby's first year. Place footprints and photos of first steps in a wooden pencil box for a charming presentation. For a child's first drawing, why not incorporate crayons into the project and mount them on a tray instead of in a frame? Capture the feeling of the first month at school with a colorful layout and journaling strips that chronicle all the memorable moments that happen in kindergarten. Each project will give you fresh ideas for your own individual designs.

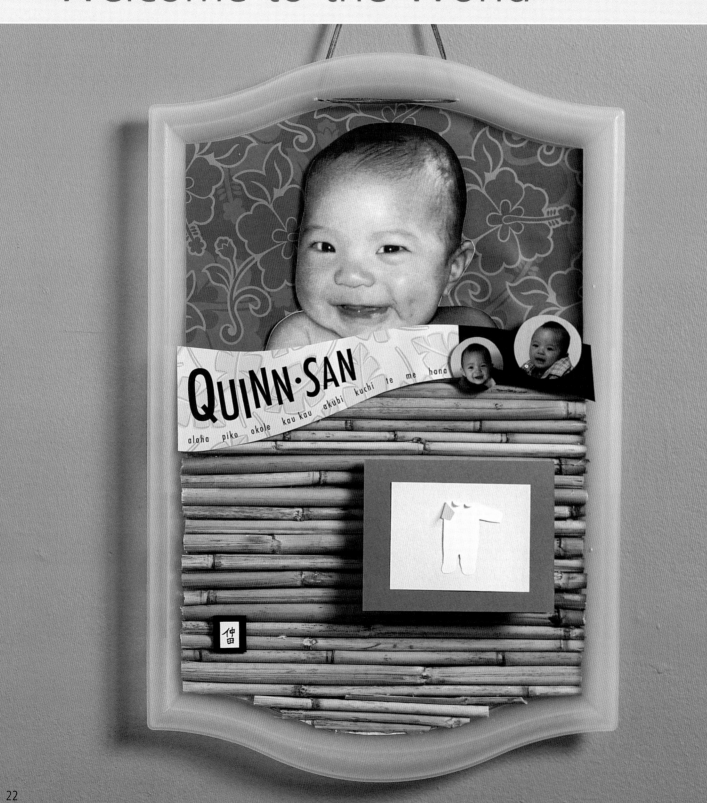

For this birth-announcement project, I emphasized Quinn's nickname, "Quinn-san," along with some Japanese and Hawaiian words he is learning. The curved border of patterned paper looks like the edge of a blanket he's peeking over! Quinn's mom is from Hawaii and both parents have Japanese ancestry, so I combined Hawaiian papers and the bamboo background in a harmonious, uncluttered way. The Japanese symbol for their last name is mounted on a simple square.

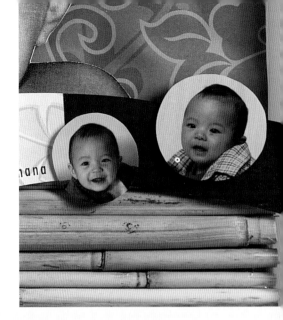

What You Need

Clear plastic tray
Drill
Print and handmade papers
Spray adhesive or adhesive of your choice
Bamboo (from a craft store)
Knife
Glue gun and hot glue
Mat board
Heavy card stock
Photos
Foam-core dots
Ribbon for hanging

What You Do

1. Drill holes in the plastic tray for later hanging.

2. Adhere the patterned papers to the tray. I added a brown rice paper under the bamboo section.

3. Cut the bamboo to size and hot glue it to the tray.

4. Scan a portrait photo and enlarge it. Print it and trim along the edges. Adhere it to a piece of mat board or heavy card stock, then attach it to the tray.

5. Print words on patterned papers and mount them on heavy card stock. Cut the piece in a curve and add a little piece of mat board at the end. Adhere a few small photos to foam-core dots, then attach them to the mat board. Attach the whole piece to the tray.

6. Attach the baby announcement to the bottom of the display. I also added a print-out of a Japanese symbol, with foam core attached to the back, over a small square of mat board.

7. String the ribbon through the hole you drilled in the top for hanging.

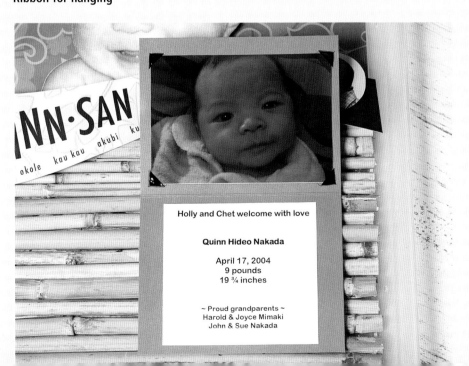

Holly and Chet welcome with love

Quinn Hideo Nakada

April 17, 2004
9 pounds
19 ¾ inches

~ Proud grandparents ~
Harold & Joyce Mimaki
John & Sue Nakada

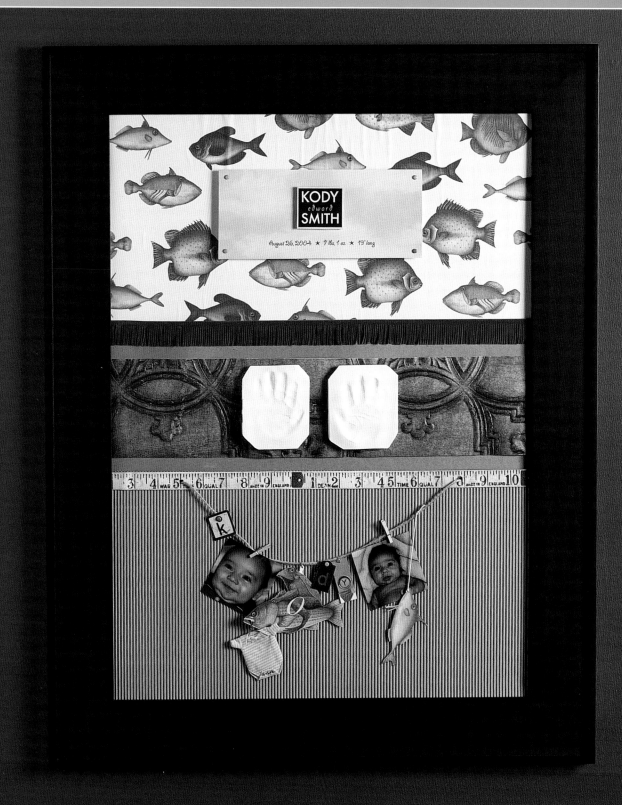

A child's hand or footprint can be a great display in his or her room. In Kody's case, his dad is a bit of a cowboy, so I embellished the display with a fringed detail and textured wallpaper that looks like leather. A clothesline holds photos and the letters of his name, plus a few fish (perfect for the son of an avid fisherman).

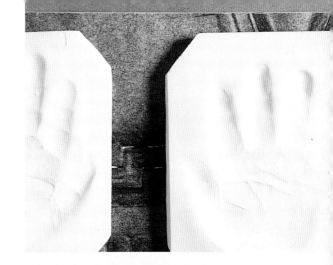

What You Need

23 x 29-inch (58 x 74 cm) wood frame
Scissors
Scrapbooking papers (including cloud-print paper, corrugated paper, and measuring-tape print paper)
Adhesive of your choice
Brads
Card stock
Foam core
Mat board
Textured wallpaper
Wood stain gel
Leather fringe scrap
Hole punch
Twine
Letters, stickers, mini-clothespins, and other embellishments
Photos
Modeling plaster
Industrial adhesive
Glossy white paint (optional)

What You Do

1. Divide the background mat into three sections and adhere a different paper to each.

2. Print the child's birth date information onto blue cloud paper, then trim and mount the paper on card stock. Add colorful brads at the corners. Attach the piece to foam core and add it to the top section of the display. Print the child's name on a separate, smaller piece of solid-colored paper, trim, and attach to mat board, then attach foam core to the back, and add it over the cloud-print paper.

3. Trim the textured wallpaper to fit in the frame, and rub gel wood stain on it for a leather look.

4. Add leather fringe and measuring-tape paper to the borders between the different sections of the display.

5. Punch holes in the measuring-tape paper and run twine through it. Attach the photos and embellishments to the twine, then tie the twine in back of the mat board.

6. Make hand or footprints with modeling plaster, and attach them to the display with industrial adhesive. (I also painted in the handprints with a glossy white paint.)

Variation

• Faded footprints could be darling on the bottom of a framed christening dress.

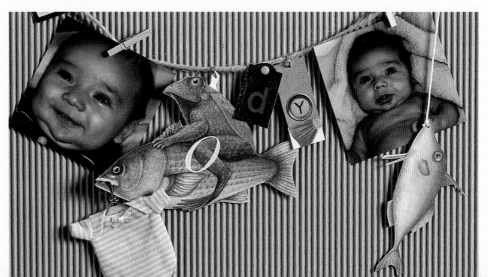

Twinkle Toes

First steps at a photo shoot where your child is the model? What could be
more perfect? I took these first images of my book editor's daughter and
tucked them into a wooden pencil box. A footprint on the inside is part of the
background. The sliding front lid emphasizes the title "Twinkle Toes," with a
star ornament topped with little Maeve's initial.

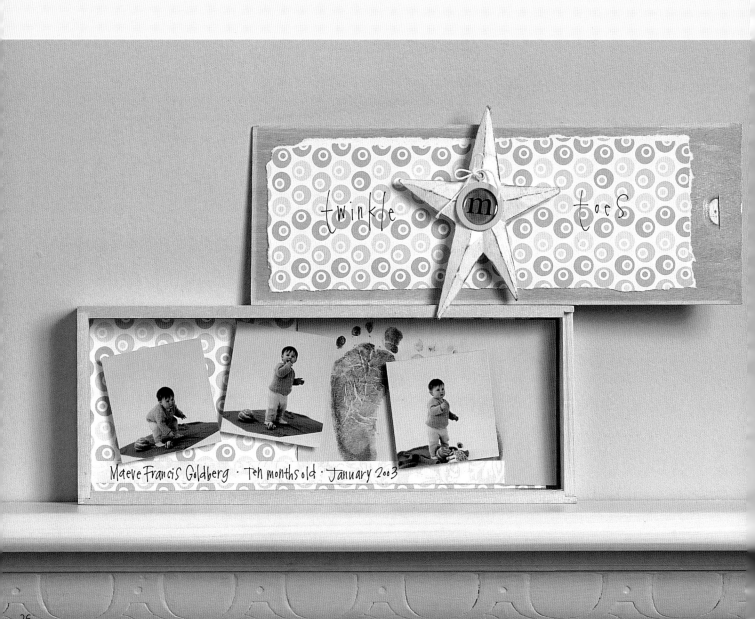

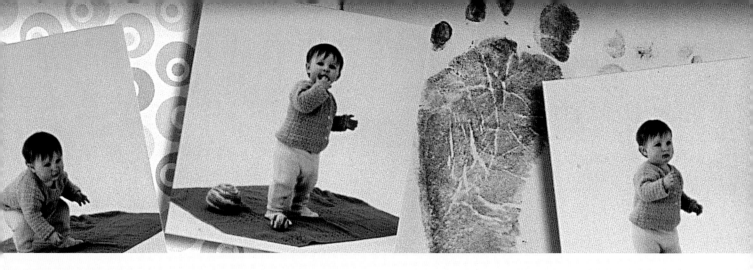

What You Need

Wooden pencil box (this one is 10½ x 4 x 1½ inches [27 x 10 x 4 cm])

Scrapbooking papers in complementary patterns

Paint pen

Scissors

Spray adhesive

Photos

Mat board

Foam core

Baby footprint

Star ornament

Industrial adhesive

Scrapbooking charm and sticker

What You Do

1. Tear the scrapbooking paper to fit the lid, and trim the paper to fit inside the box. Adhere the paper to the box with spray adhesive. Write "twinkle toes" on the lid with a paint pen.

2. Attach the footprint inside the box. Write the child's name and details of the first steps on a piece of scrapbooking paper in a color that contrasts with the one you already used. Attach the name inside the box with spray adhesive.

3. Mount the photos on mat board, then attach them to foam core for dimension, and attach them inside the box.

4. Attach the star ornament to the lid using foam core and industrial adhesive. Add a charm with a string and initial sticker to top.

Variations

• Paint the box with colorful acrylics and paint pens.

• Try a different orientation with the box (vertical instead of horizontal).

• A drawer pull can be used instead of the star ornament (but be careful where you position it so you can still slide open the lid).

• The pencil box can be hung on a wall by simply drilling holes and threading string or using a picture hanger screwed on the back. It also looks cute as a tabletop display.

• Drill holes and hang objects or charms from the bottom of the box.

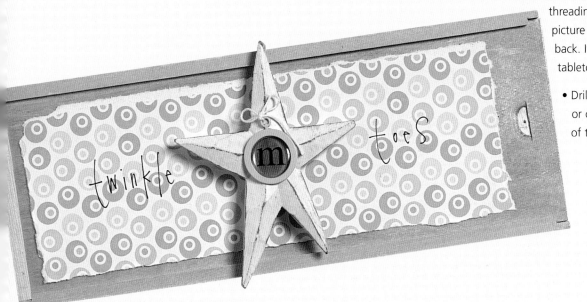

Budding Artist

I love kids' artwork. This cat is one of my daughter's first recognizable drawings. It has a lot of personality with its eight legs, curly tail, and quiet smile. This is a colorful way to display any piece of children's art, and the design allows you to substitute future drawings if you like.

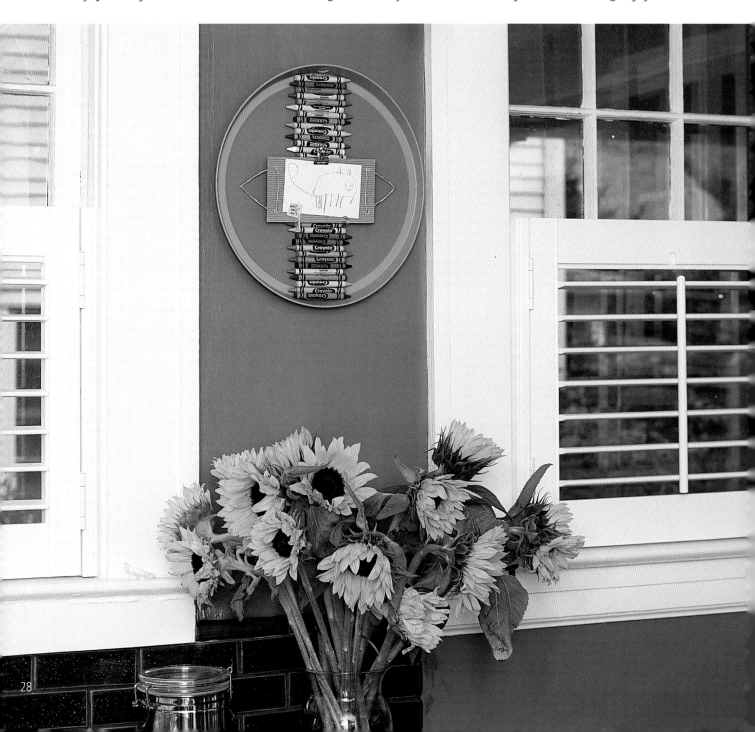

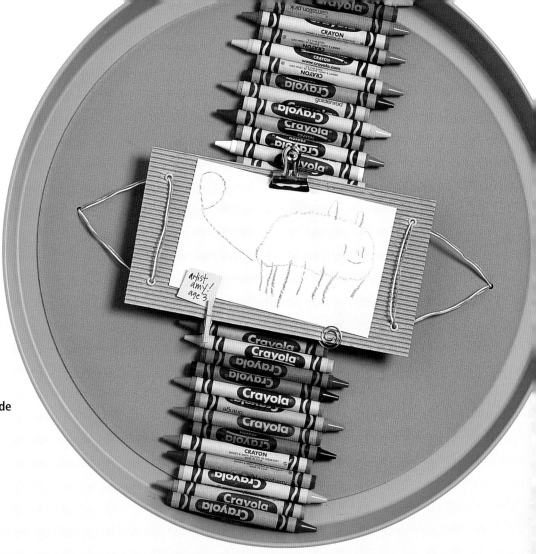

What You Need

Drill

Round plastic tray

Fresh box of crayons

Glue gun and glue sticks

Scissors

Corrugated cardboard (can use inside of lightbulb boxes)

Child's artwork

Craft glue

Foam core

Binder clip, paper clip, mini-clothespin, or glue

Eyelets

Electrical wire (I used only the green-colored strands)

Masking tape

What You Do

1. Drill holes in the plastic tray—one in the top to hang the piece and one in each side of the center of the tray for attaching the artwork.

2. Hot glue a row of crayons onto the tray.

3. Cut a rectangle of corrugated cardboard to the size of your choice for mounting the artwork. Connect the artwork to the corrugated card-board with binder or paper clips, a mini-clothespin, or glue. Adhere a piece of foam core behind the corrugated cardboard for dimension.

4. Add eyelets to the cardboard and thread the electrical wire through. Thread the wire through the eyelet holes and then through the holes you drilled in the tray. You can secure the wire on the back of the tray with masking tape to keep it flat.

5. Add the child's name and age on a scrap of paper and attach it to corrugated cardboard with a mini-clothespin.

Variations

• A row of colored pencils in a standard frame, positioned vertically or horizontally, would work beautifully also.

• Consider using a chalkboard or a cork bulletin board instead of a tray.

• Hang the tray from a jump rope.

• I used brand new crayons, but it might be fun to use a few used ones or shavings from sharpening in the display.

• This display looks great on its own or in a grouping with a few other kid's drawings, framed in a more traditional style.

Starting School

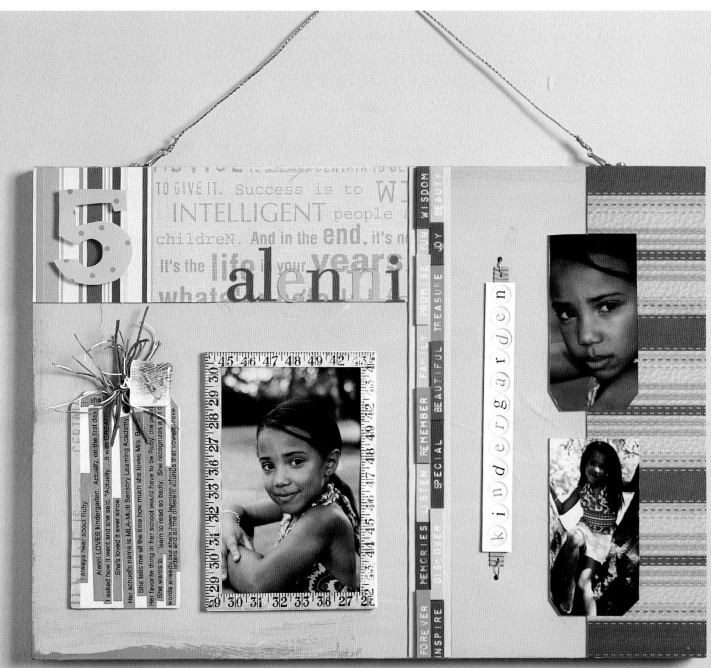

The first few months at kindergarten are exciting and memorable—so many new things to absorb. This piece captures Alenni during that time in her life. The project uses a piece of artist's board I used when testing colors out for the walls of my house. Alenni's vibrant personality seemed to work well with the green textured background, so I used it and added colorful scrapbooking papers. With only three photos of her and an email from her mom (about her first month of school), I was off!

What You Need

Artist's board

Paint, in colors of your choice

Paintbrush

Drill

Eye screws and picture-hanging wire

Mat board

Scissors

Scrapbooking papers in various coordinating patterns (including ruler-print paper)

Spray adhesive

Foam core and foam-core dots

Pencil

Craft glue or industrial adhesive

Scrapbooking letter stickers

Photos

Decoupage medium

Wooden tag

Electrical wire and wrapping twine

Bunny charm

Pebble and dome stickers

Heavy card stock

Corrugated cardboard scraps

Medium-gauge wire

What You Do

1. Paint the board in the colors of your choice. Drill holes in the top of the board and attach the framing hardware.

2. Cut mat board to a size that fits with your design, and attach scrapbooking paper over the mat board with spray adhesive. To add more dimension, you can add the child's name over the paper with stickers or cut out the child's age from patterned paper and attach it with foam-core dots. To give the letters more dimension, I traced around them with a pencil. Attach the mat board to the artist's board with craft glue or industrial adhesive. I added the printed words of inspiration over a piece of solid scrapbook paper, then attached them directly to the artist's board, using foam-core dots behind some of the words to give them dimension.

3. Mount the photos on mat board with spray adhesive. I attached one photo to a piece of foam core, then made a "frame" for it from ruled paper decoupaged around the edge of the photo. Attach the photos to the board with industrial adhesive.

4. Print commentary onto craft paper, then cut it out and decoupage it to the wooden tag. Decoupage a strip of scrapbooking paper to the edge. Drill two holes where you want the tag to go, then loop electrical wire through the holes to attach the tag. Add a little bundle of cut-electric wire through the loop, and attach a charm. For this project, I used a bunny charm, since Ruby the class bunny was one of Alenni's favorite things about kindergarten. I made the bunny charm by cutting around a greeting-card illustration and leaving a half circle at the top. I punched a very small hole in this

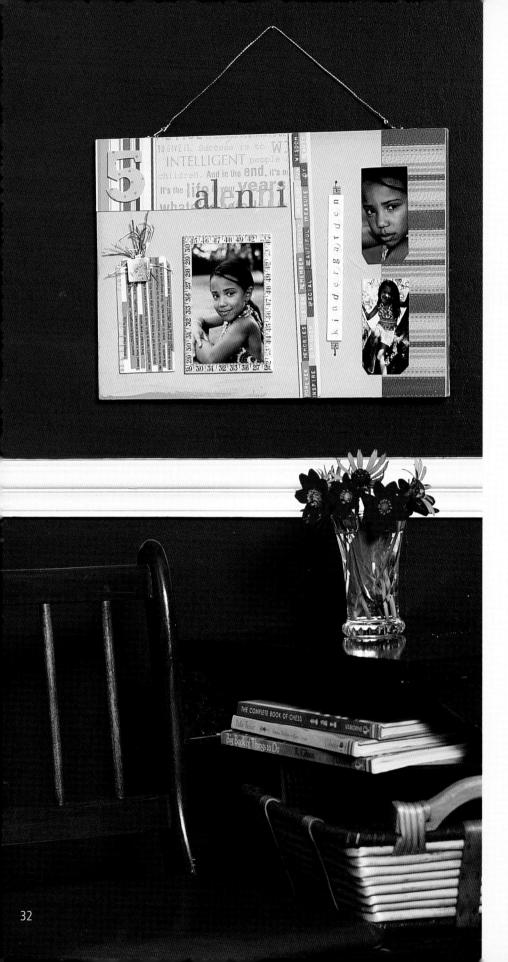

half circle and covered the bunny image with a square dome sticker, then trimmed it tightly with a craft knife.

5. To add the word "kindergarten," attach pebble letters to a piece of heavy card stock. Glue little strips of corrugated cardboard to the back side of the card stock, then poke a small piece of wire through the cardboard. Drill two holes for each side of the piece, then loop a piece of wire through them.

Variation

• I like the look of the stitching on one of the patterned papers. It would be fun to scan a favorite outfit (or one worn on the first day of school) and print a color copy as your own custom paper.

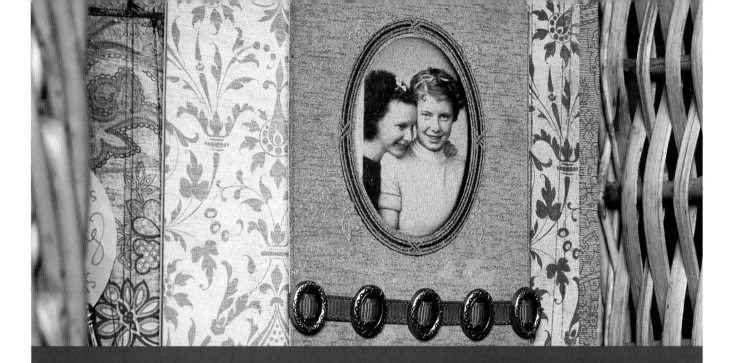

Friends and Family

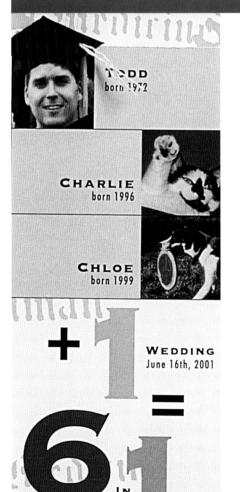

Your favorite photos, no doubt, are the ones of your favorite people—your friends and family. This section of the book will give you inspiring ideas for giving your most cherished photos the star treatment. Think of your frame not as a finished border, but as a starting point for some creative additions, such as beads or a filmstrip. Use an unexpected object—a lovely wicker basket, a pizza pan, or an old cabinet door—as an interesting alter-native to a traditional frame. Make your piece functional as well as decorative—a photo display can become a tie rack or a leash holder. Adapt any of these ideas to make them uniquely your own.

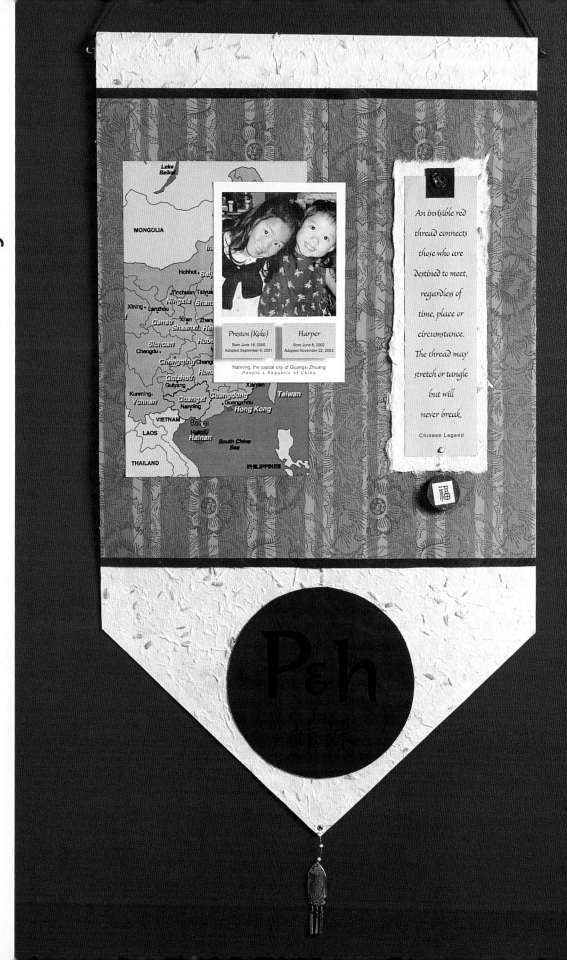

An invisible red
thread connects
those who are
destined to meet,
regardless of
time, place or
circumstance.
The thread may
stretch or tangle
but will
never break.

Chinese Legend

Preston (Koko)
Born June 18, 2000
Adopted September 9, 2001

Harper
Born June 8, 2002
Adopted November 22, 2003

Nanning, the capital city of Guangxi Zhuang
People's Republic of China

These sisters were adopted from the same city in China. I made this project to celebrate their heritage, so I incorporated a Chinese legend about a red thread into the design. The ladybug and the symbol on the dangling charm both mean good luck. The little string of pearls represents their birth city, which is famous for its pearls.

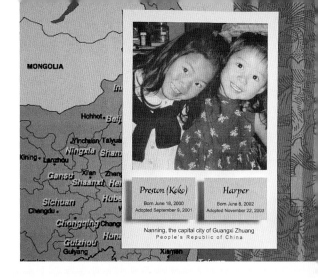

What You Need

Ruler

Pencil

Oversized handmade papers (the cream-colored paper is a fuchsia-seed paper)

Craft glue

Patterned papers (the orange papers are cut up from a set of greeting cards)

Spray adhesive

Map

Charms, eyelets, eye hooks

Pearls on a string (these came from a gaudy napkin ring)

Old pair of fish earrings

Foam-core dots

Card stock

Foam core

Photo

Glue gun and glue sticks

Awl

Eye hooks

Thin strip of wood

Red thread

What You Do

1. Measure and trace your banner shape onto the handmade paper. Mine is a 15 x 20-inch (38.1 x 50.8 cm) rectangle with a 7-inch-long (17.8 cm) triangle. Score a line 1/4 inch (6 mm) from the edge around the sides of your paper. Fold in and glue the edges. Score a line about 1 inch (2.5 cm) from the top and fold twice (this is the pocket for your wood strip). Glue the pocket.

2. Add patterned paper to the banner. I used cut-up note cards. Add trim at the edges for a border (I used a red marbled paper). Spray-mount the paper to the banner.

3. Print initials, a poem, Chinese symbols, and a map onto various papers and spray-mount them to the banner. I added an eyelet to the printout of the poem and strung the pearl embellishment through it, then attached a patterned-paper colored charm to the end. I added Chinese symbols on top of the charm. Then I mounted the whole poem to a torn piece of handmade paper before attaching it over the

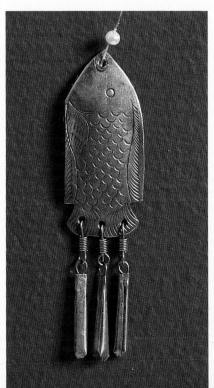

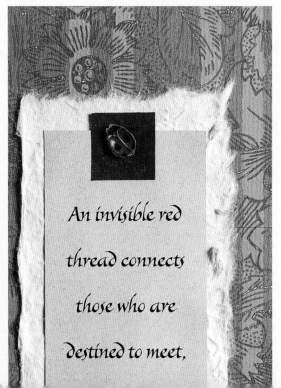

An invisible red thread connects those who are destined to meet,

35

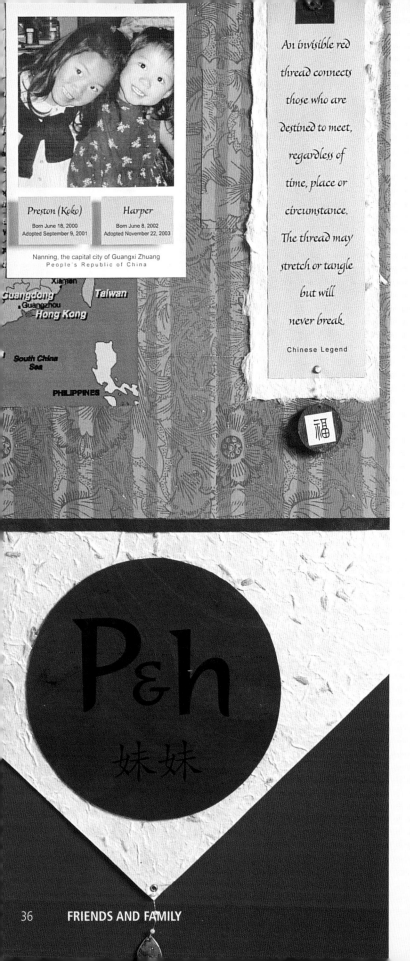

An invisible red thread connects those who are destined to meet, regardless of time, place or circumstance. The thread may stretch or tangle but will never break.

Chinese Legend

Preston (Koko)
Born June 18, 2000
Adopted September 9, 2001

Harper
Born June 8, 2002
Adopted November 22, 2003

Nanning, the capital city of Guangxi Zhuang
People's Republic of China

patterned paper. I trimmed a ladybug image from a greeting card and adhered it to a foam-core dot over a square of patterned paper above the poem. I drew the ladybug's legs on the background paper.

4. I printed out the girls' names on card stock and attached foam core to the back. I attached the names over a photocopy of a photo of them, with the name of their home city printed at the bottom.

5. At the base of the banner, add an eyelet and thread some more of the pearl embellishment through it. If you have a charm or other embellishment, hot-glue it to the bottom of the pearl embellishment.

6. Using an awl, make holes for the eye hooks at each end of your wood strip. Twist in the eye hooks and glue them in place. Slide the wood through the banner pocket, and string red thread through each eye hook to hang the banner.

Variations

• Use canvas instead of handmade paper for a different look and feel.

• This could be a great sewing project—use the red thread as a motif.

Old Friends

I used a vintage basket to house a display that commemorates two old friends. Bits of silver, a flower tied to the inside, and a list of their favorite things make this piece unique and personal.

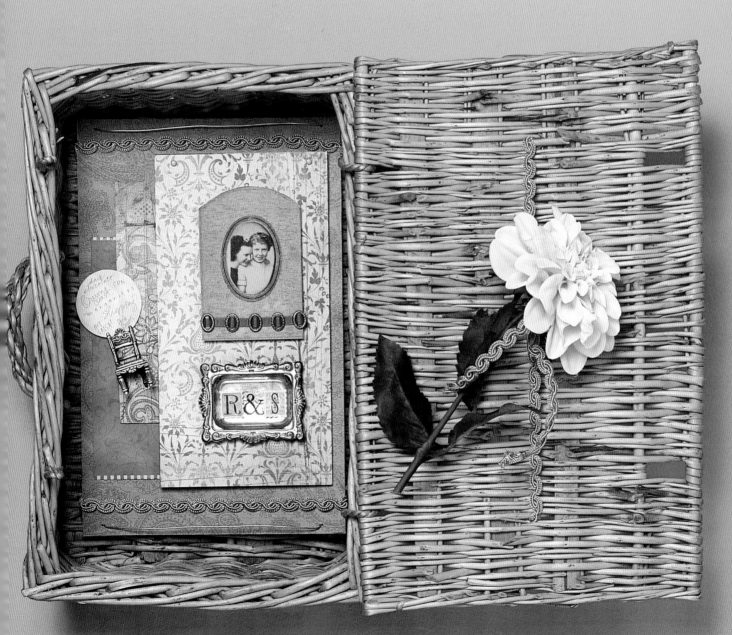

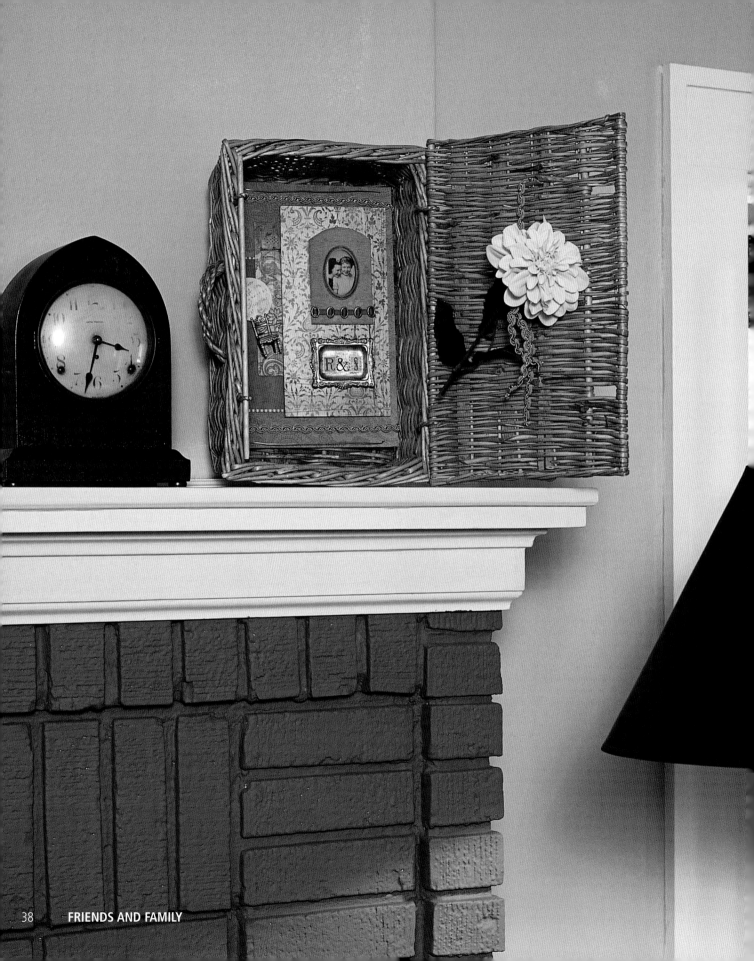

What You Need

Mat board

Scissors or craft knife

Wicker basket

Craft glue

**Scrapbooking papers in comple-
mentary designs**

Foam core

Sewing trim

Postage-stamp letter stickers

Vintage silver tray

Industrial adhesive

Ribbon

Scrapbooking charms

Card stock

Silver chair place card holder

Hole punch

Wire cutters

Wire

Silk or dried flower

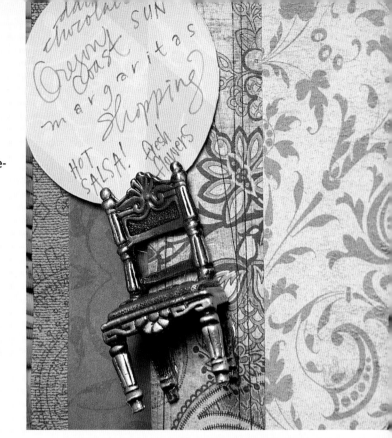

What You Do

1. Cut the mat board for the
background to fit inside the basket.
Cut two smaller pieces of mat board to
add on top of it for a layered look.
Adhere the scrapbooking paper to the
mat boards, then arrange the mat
boards in the design of your choice. I
put a piece of foam core under the top
mat board to give it more height. When
you have an arrangement you like,
adhere the pieces together with the
largest piece of mat board on the
bottom. I added sewing trim to the
large, bottom mat board for a nostalgic
touch.

2. Add the initial letter stickers to the
silver tray, then adhere the tray to the
top mat board with industrial adhesive.

3. Decorate the photo frame with ribbon and charms, then adhere it to the top mat board.

4. Cut a circle out of card stock and record favorite "friend" activities. Slide it into the chair place card holder, and attach the holder to the mat board with industrial adhesive.

5. Punch holes in the bottom mat board to thread the wires through, and attach the piece to the basket. Twist the wire in the back to secure it.

6. Thread a piece of ribbon or sewing trim through the basket lid, adding a ribbon charm. Position the charm on the top of the lid. Adhere the ribbon to the basket with industrial adhesive. Inside the lid of the basket, tie the ribbon and insert a flower in the tie.

7. Hang the basket on a simple nail or from a ribbon, or use it as a tabletop display.

Variations

- Memories in a basket would be a fun way to remember a family reunion picnic.

- This idea works for many themes or time periods ('50s, 1900s, anniversary, birth announcement, etc.).

- Small frames, collaged and layered inside a basket, could be stunning.

Ties That Bind

This project could be created for either a man or a woman. I made this one with my husband in mind. I took a thick, wooden tabletop frame and added three masculine silver hooks to the bottom for hanging ties or belts, but it could just as easily be used for hanging necklaces. Adapt the idea however you like—it's a great way to combine form, function, and fun.

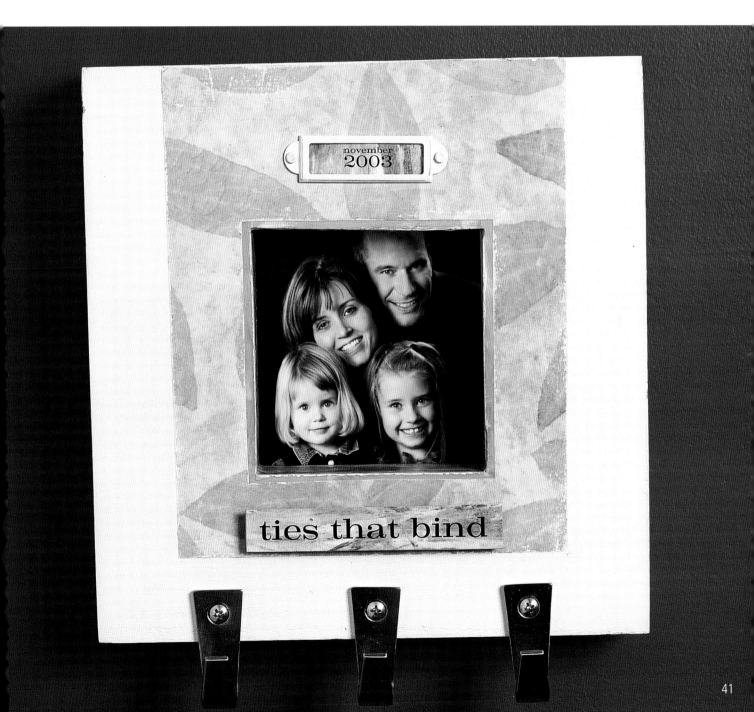

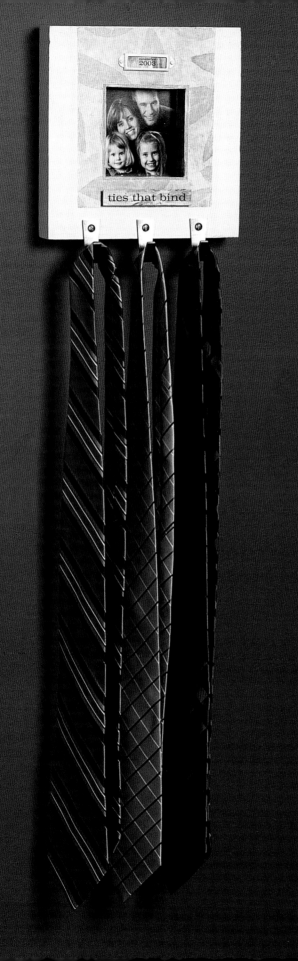

What You Need

Acrylic paint
Paintbrush
Thick wooden frame (this one is meant to be on a tabletop)
Frame-hanging hardware
Drill
Scrapbooking papers
Decoupage medium
Sandpaper
Eyelets
Hammer
Scrapbooking metal label
Industrial adhesive
Felt-tip marker
Metal hooks

What You Do

1. Paint the edge of the frame's opening, using a color similar to the papers you'll use. Let the frame dry.

2. Drill holes for the hooks at the bottom of the frame. Add the hanging hardware to the back.

3. Decoupage papers to the frame to create the look of a mat. Seal and sand the edges of the paper.

4. Lightly hammer eyelets around the metal label to secure them in place and add a dab of industrial adhesive.

5. Print the date on the paper and slip it into the metal label.

6. Hand-letter the text you want to add to the piece using a felt-tip marker.

7. Attach the hooks.

Variations

• Attach a tie to the back of the display and hang it from a wall-mounted hook.

• For a really masculine look, paint the frame black, and use a dark striped paper and a shiny metal label.

• For a *really, really* masculine look, use distressed leather as a mat, and nail upholstery tacks or rusty nails around the opening.

ties that bind

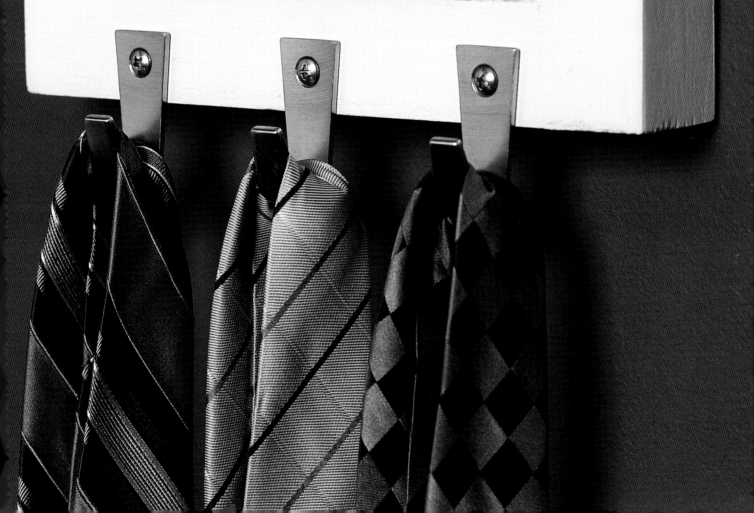

Birds of a Feather

Libby & Kate
FUN

friends

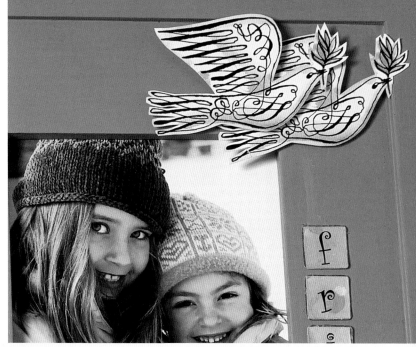

Think of your frame as the jumping-off point for a really creative display. Add letters, charms, papers, words in your own handwriting—the list is endless. I cut the birds on the frame from an old greeting card to represent two girls who are "birds of a feather."

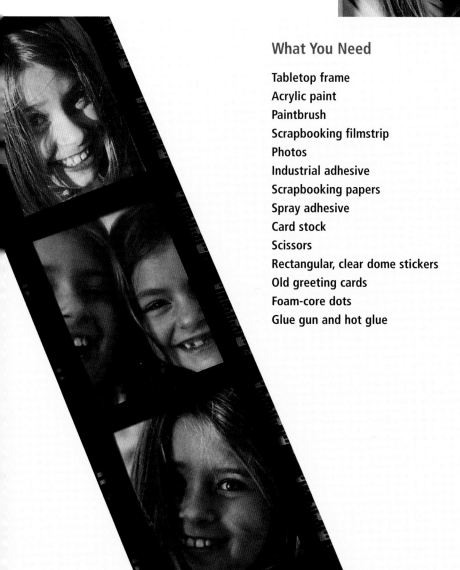

What You Need

Tabletop frame
Acrylic paint
Paintbrush
Scrapbooking filmstrip
Photos
Industrial adhesive
Scrapbooking papers
Spray adhesive
Card stock
Scissors
Rectangular, clear dome stickers
Old greeting cards
Foam-core dots
Glue gun and hot glue

What You Do

1. Prime and paint a tabletop frame.

2. Crop your photos to fit inside the filmstrip and adhere it to the frame.

3. Print letters onto scrapbooking paper, spray mount them to card stock, trim and adhere them to the frame. Add dome stickers over the letters.

4. Cut out birds from a greeting card and attach them to the frame with foam-core dots and hot glue.

5. Print out the friends' names on scrapbooking paper and attach the paper as a border over the glass of the frame. Slide your photo into the frame.

Variations

• A photo strip from a photo booth would be a great alternative.

• Instead of photos, use letters in the filmstrip to spell out a word.

Wanna Go for a Walk?

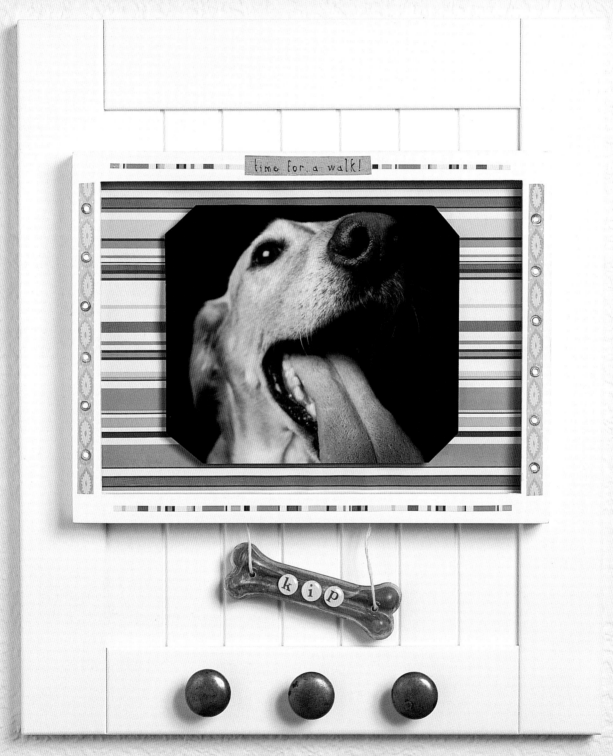

My dog Kip is one of the sweetest dogs around. I love this photo because of his huge pink tongue and black nose. This project is a great way to display it, and it doubles as a leash holder. Behind the photo is a scrap of wallpaper from my powder room. I added punches and round stickers to paper strips on the sides to create the appearance of a dog collar. An actual dog bone is the nameplate.

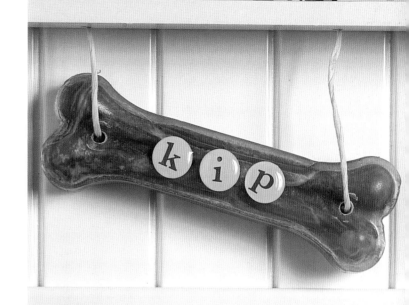

What You Need

Drill
Wooden frame
Dog bone
Craft twine
Scrapbooking pebble letters
Wallpaper scrap
Foam core
Dog photo
Adhesive of your choice
Nails
Hammer
Cabinet door
Decoupage medium
Scrapbooking papers and stickers
Hole punch
Antique brass knobs
Hanging hardware

What You Do

1. Plan your arrangement and drill two holes in the bottom of the wooden frame and two holes in the dog bone. Run twine through the holes to attach the bone to the frame.

2. Add pebble letters to the bone to spell out your dog's name.

3. Cut a wallpaper scrap and fit it inside the frame.

4. Cut the photo to the size you want and mount it on foam core. Adhere the foam core on top of the wallpaper scrap.

5. Nail the frame to the cabinet door.

6. Cut some scrapbooking paper and wallpaper strips, then decoupage them to the edges of the frame as trim to cover the nail heads. I printed "time for a walk" on one strip. I punched holes through the strips on the side and added bolt stickers for a dog-collar look.

7. Drill holes on the bottom of the cabinet door and attach the knobs.

8. Attach hanging hardware to the back of the cabinet door.

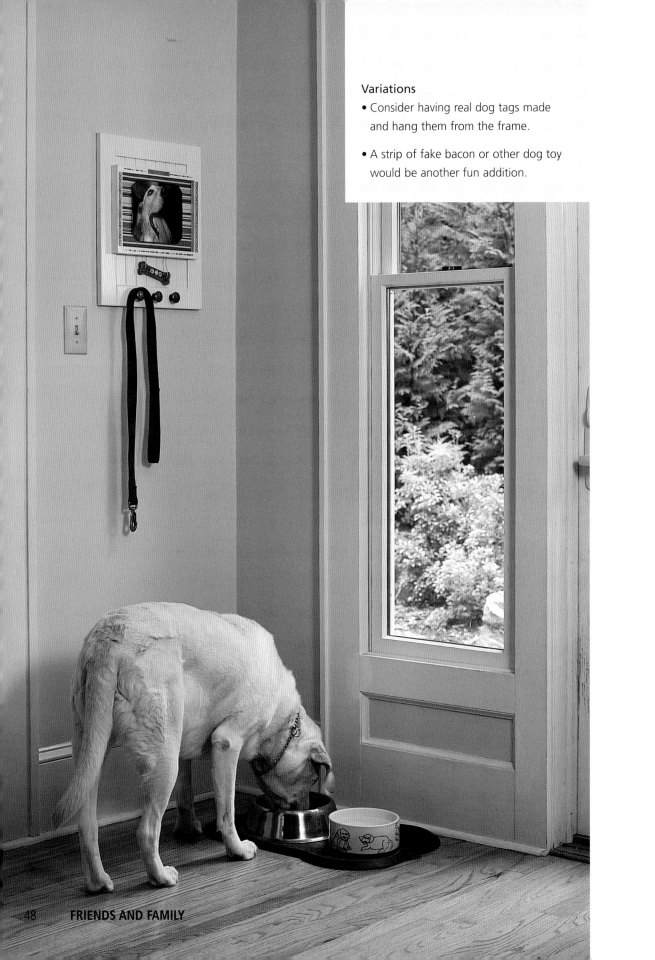

Variations

• Consider having real dog tags made and hang them from the frame.

• A strip of fake bacon or other dog toy would be another fun addition.

Gift Portrait

This is a much more expressive way to frame a traditional portrait—crop a photo tightly and layer it with pattern. It was designed as a grandparent's gift. The little "necklaces" hang down with aged initials, adding a strong dimensional element.

What You Need

13 x 15-inch (33 x 38 cm) wooden frames
Portrait photo
Hole punch
Mat board or card stock
Scrapbooking papers
Mat board background (I sanded mine down so it looks like suede)
Spray adhesive
Wooden tags
Wood stain
Cardboard alphabet initials
Sandpaper
Ribbon, twine, or wire (to make necklaces)
Masking tape
Foam core

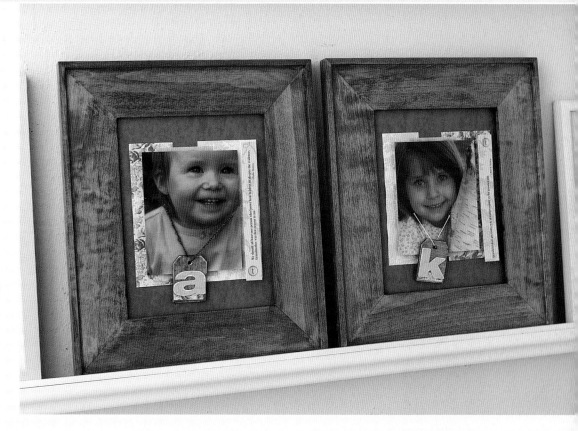

What You Do

1. Color copy each portrait photo. Hole punch where the necklace will be inserted. Mount each photo on card stock or mat board.

2. Layer scrapbooking papers on the frame's mat board with spray adhesive.

3. Stain the wooden tag. Add a scrap of paper and a paper-covered cardboard initial to the tag. Sand to age.

4. Thread ribbon, twine, or wire through the tag and holes punched in the photo. Tape the necklace to the back of the photo for extra security. Mount the photo on foam core for height.

Variations

• The little necklaces can hold initials, nicknames, mini-portraits, and references to the child's hobbies—however you want to think of the personality behind the face in the frames.

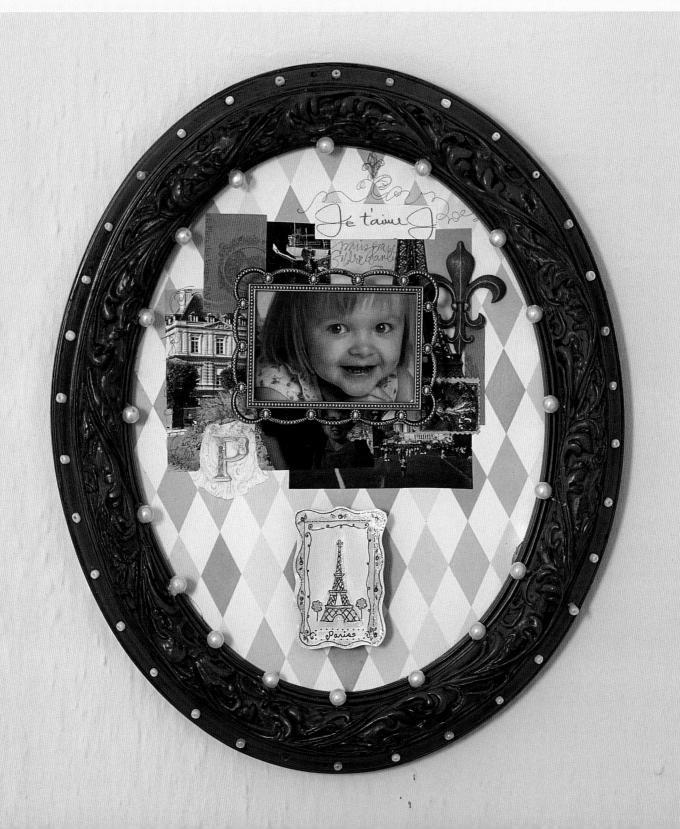

My friend LeeAnn loves the city of Paris so much that she chose the name for her daughter. This project is a tribute to little Paris and her namesake city. I combined decoupaged photos, bits of stationery, and beads around the frame to evoke a French feeling. You can adapt this idea for any child who has a distinctive name.

What You Need

Oval frame
Acrylic paint (optional)
Wood gel-stain
Paintbrush or cotton swab
Pearls and beads
Glue gun and hot glue
Patterned and solid
 scrapbooking paper
Decoupage medium
Photos
Charm
Miniature letter
Industrial adhesive
Ribbon for hanging
Postage-stamp sticker
Spray adhesive
Note-card images
Heavy paper
Foam-core dots
Small frame
Foam core

What You Do

1. Paint the oval frame if necessary. When it's dry, rub stain into the grooves to give it an aged look.

2. Hot glue beads and pearls around the frame in the design of your choice.

3. Decoupage the patterned paper to the cardboard back of the frame.

4. Crop and arrange your photos, then decoupage them to the background paper.

5. Add the charm and letter with industrial adhesive and stick on the postage-stamp sticker. Print out any text you choose and adhere it to the background paper. I cut an Eiffel Tower image from a note card and backed it with heavy paper, then attached it to the background paper with foam-core dots.

6. Put a tightly cropped portrait of the child in the small frame. Attach foam core to the back of the frame for height, then adhere it to the background with industrial adhesive.

7. Tie a long ribbon through the back to hang.

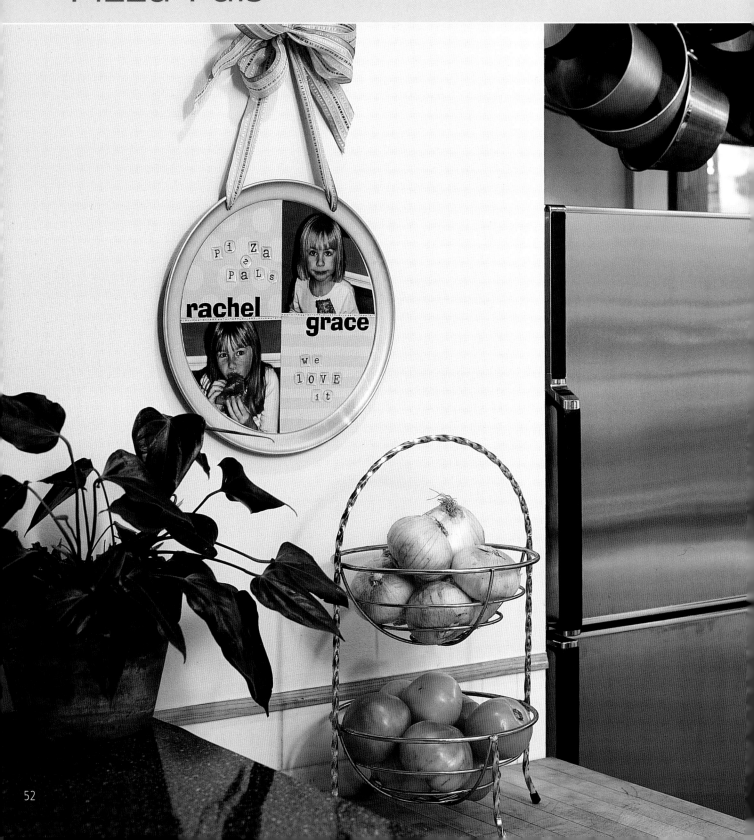

Who wants pizza? This pizza pan frame is great for a kitchen, and since it's magnetic, you can add extra photos or notes to it with magnets. It would also be fun in an entry hall or in a kid's room. It's an easy project made with simple materials.

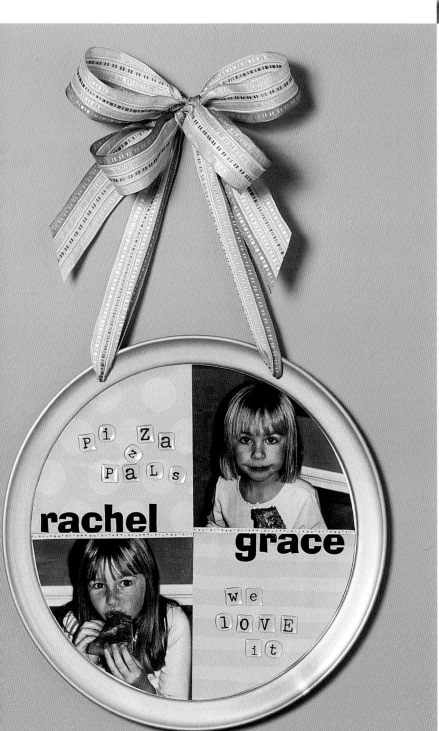

What You Need

Drill
13-inch (33 cm) pizza pan
Coordinating scrapbooking papers
Scissors
Color copies of photos
Decoupage medium
Border paper or sticker (optional)
Ribbon
Pebble letters

What You Do

1. Drill two holes in the top of the pizza pan.

2. Print the kids' names on scrapbooking papers or use letter stickers. Trim to fit.

3. Make color copies of photos. Decoupage the photos and papers to the pan. Add a border paper or sticker if desired.

4. Thread the ribbon to hang the display.

5. Add pebble letters or stickers as desired.

Variations

- Kids in aprons baking cookies on a cookie sheet, making pie in a pie plate—you get the idea…

One Plus One Equals Six

Todd and Laura are both veterinarians. When they graduated from college and married, they (and their animals) "merged." Their situation reminded me of the Brady Bunch. I screened their diplomas in the background and I arranged headshots of them and their pets over. The little handmade corrugated caps complement their photos, taken at graduation.

What You Need

Diplomas
19-inch (48 cm) square frame
Spray adhesive
Scissors or craft knife
Black corrugated paper
Heavy mat board
Cardboard
Industrial adhesive
Hole punch
Thin string
Round metal washer

What You Do

1. Scan the diplomas and arrange them with a starburst in the upper left that says, "merge." Color print the document to use as the background art. Spray mount this piece to frame's cardboard backing.

2. Scan the photos and arrange them in a grid. Call out the names and dates, and add numbers to your layout. Color print the document. Spray mount it to heavy mat board and back it with cardboard for greater dimension. Attach the cardboard to the background with industrial adhesive.

3. Trim the corrugated paper in the shape of a graduation cap (one for each person). Hole punch through each cap and thread thin string through. Attach over actual graduation caps in the photos.

4. Attach the metal round washer over the word 'merge' with industrial adhesive.

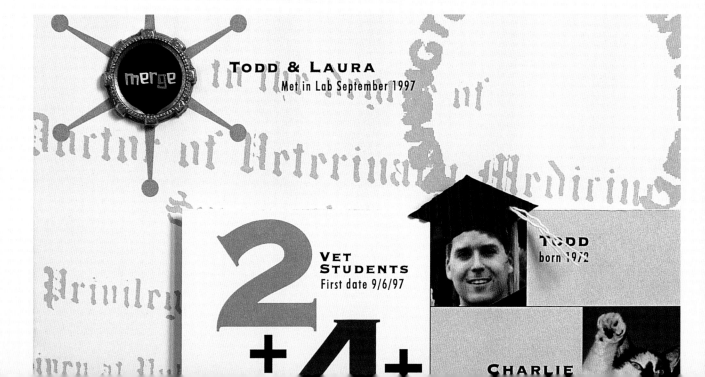

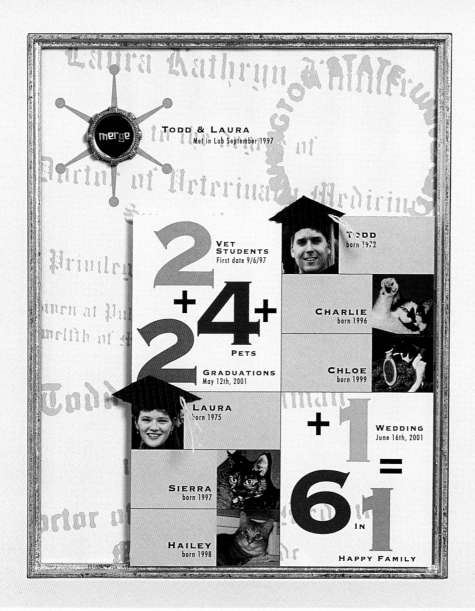

TODD & LAURA
Met in Lab September 1997

2 VET STUDENTS First date 9/6/97

2 + 4 + PETS

2 GRADUATIONS May 12th, 2001

TODD born 1972

CHARLIE born 1996

CHLOE born 1999

LAURA born 1975

+ 1 WEDDING June 16th, 2001

= 6 1 IN HAPPY FAMILY

SIERRA born 1997

HAILEY born 1998

merge

Variations

• I did this layout digitally, but it can be easily recreated by cropping actual photos and using three-dimensional number stickers. You could also decoupage scanned photocopies of the diplomas to your background.

• Go linear—think of this layout as a timeline and call out important dates along it.

• Consider decoupaging the mat with pages from a textbook. Since these two are veterinarians, cat and dog illustrations would have been cute.

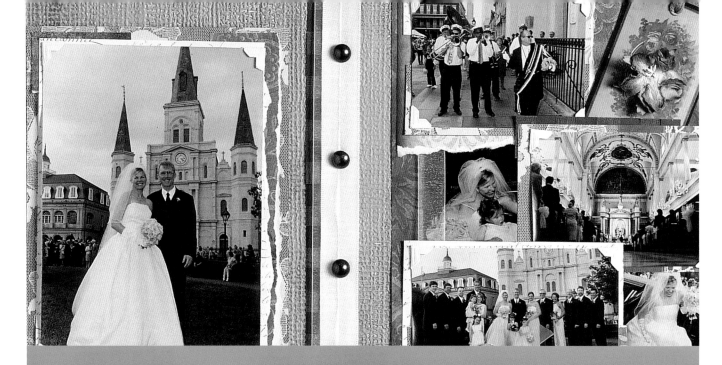

Celebrations

Special events deserve special recognition. This section presents some uncommon ideas for commemorating holidays, weddings, birthdays, and other notable occasions. Instead of a frame, why not try a piece of painted canvas? You can display the canvas in an easel like a work of art or hang it on a wall. Add layers of texture to a wedding display, evoking the unique mood and feel of the event. Use invitations or favors from the event as part of your layout. Stagger the height of your photos for more dimension. Combine these techniques with all your wonderful photos and memorabilia for a piece that really shines.

French Quarter Wedding

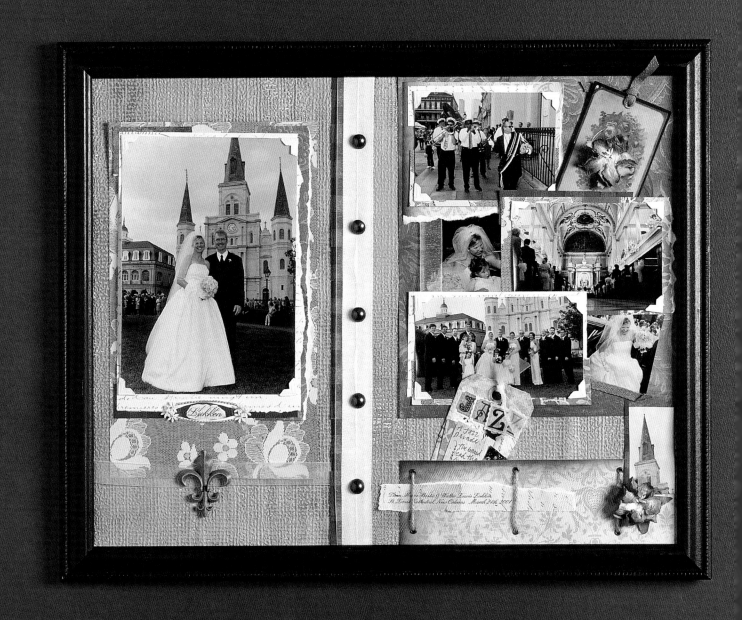

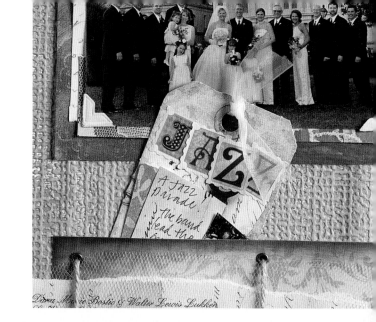

This is one of my favorite projects. It's romantic and feminine, and I think it has an aged elegance like New Orleans itself. I used painted wallpaper as a background and layered and layered. To adapt the project, think of the unique aspects of the wedding—its location, style, and memorable moments.

What You Need

16 x 20-inch (41 x 51 cm) wood frame
Textured wallpaper
Adhesive of your choice
Acrylic paint (optional)
Paintbrush (optional)
Assorted patterned papers
 (I used floral, lace-patterned,
 floral-patterned, checkered, and
 lettered paper)
Ribbons and tulle
Brass upholstery tacks
Photos
Photo corners
Scrapbooking charm
Scrapbooking flowers, tags, stickers,
 and labels
Hole punch
Eyelet
Twine
Paper flower

What You Do

1. Start by mounting a piece of textured wallpaper to the frame's back mat. I used mustard yellow and dry brushed two brown colors on top of it.

2. Choose where you want to divide the layout, making it a little off-center.

Adhere strips of paper down this line, then add ribbon on top of them, securing them in place by nailing upholstery tacks over them into cardboard (I turned over the frame and pounded the sharp tips back, then taped a large sheet of cardboard to the back for protection).

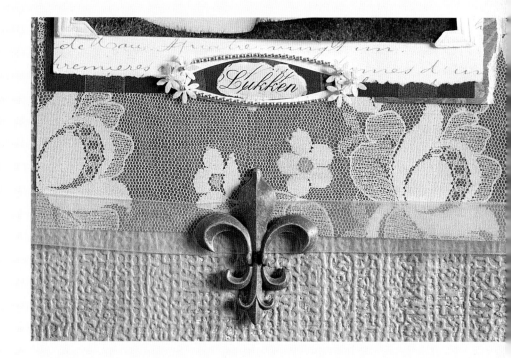

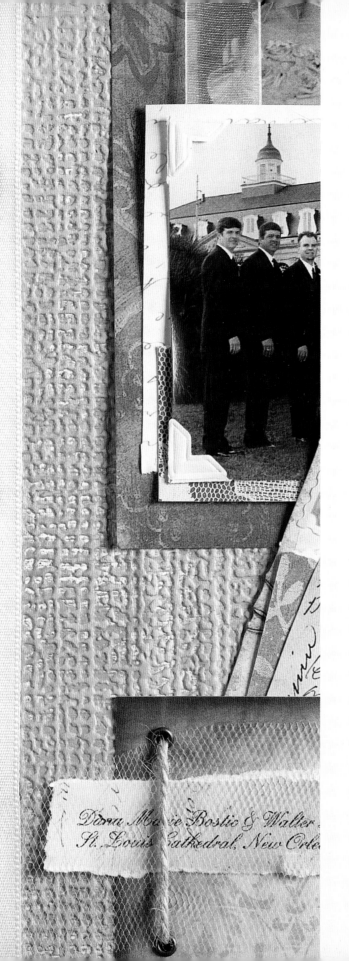

3. Mount your focal point photo on layers of patterned paper. Print the couple's name on patterned paper and adhere it to the piece over a few more layers of patterned paper. I added flowers and a metallic accent around the name. This couple was married in New Orleans, so I added a charm shaped like a fleur-de-lis, the city's symbol.

4. On the other side of the layout, layer more papers and smaller photos. Add photo corners to the photos. I tucked a tag with a paper flower onto the side and added a bit of ribbon between photos.

5. Punch holes through a piece of patterned paper and add eyelets to it. Punch corresponding holes in the back mat of the frame and string twine through the holes, tying it in back. This creates a pocket. I put a tag in the pocket, adding stickers and layering paper, then writing memorable moments from the wedding on top. I embellished the pocket with a paper flower.

6. Print the couple's name and date and place of wedding on a piece of patterned paper, tear the edges, and adhere it to the pocket. I layered a piece of tulle over the title.

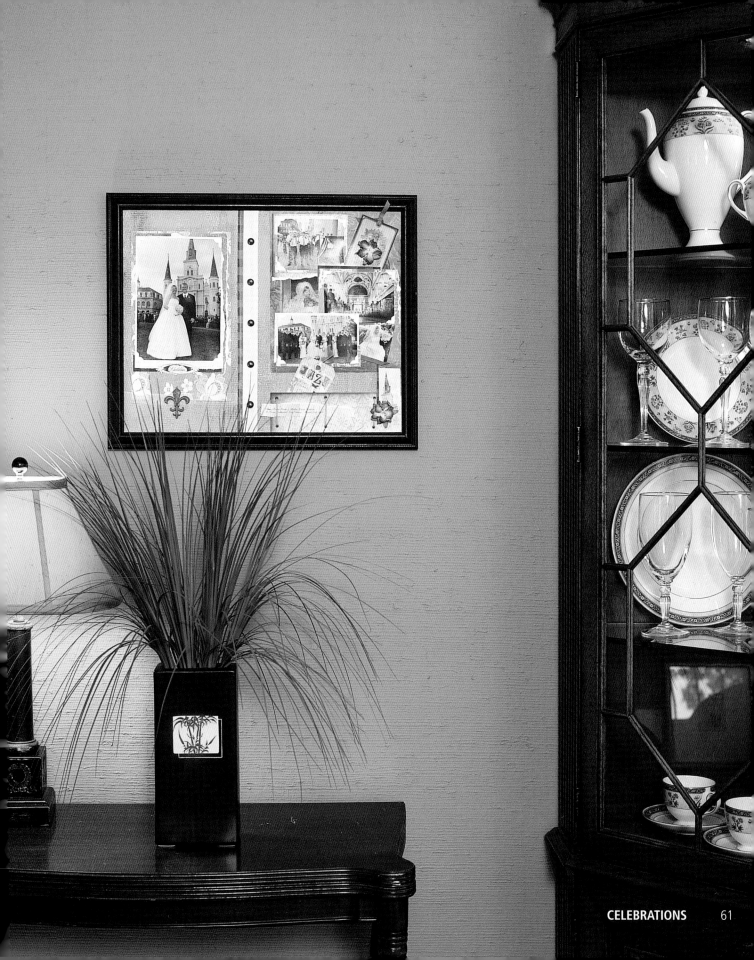

A Rite of Passage

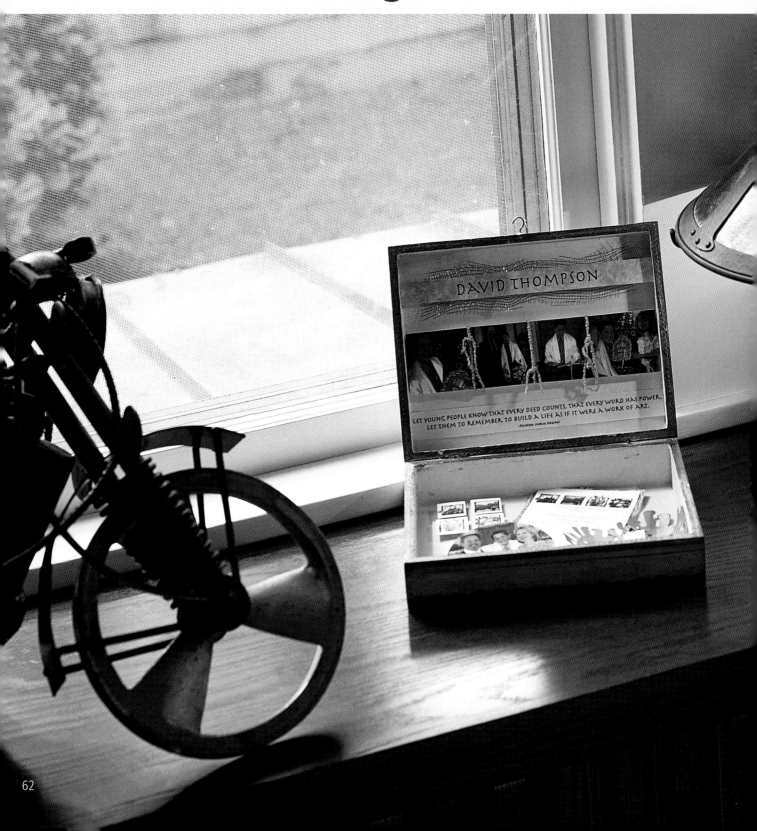

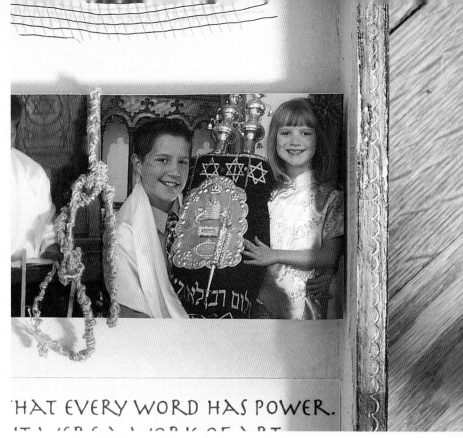

HAT EVERY WORD HAS POWER.

To commemorate David's bar mitzvah—a Jewish rite of passage for 13-year-old boys—I wanted to make something really personal. I must have done this project three different times. First I used a lot of gold spray paint, curves, and embellishment. But it didn't reflect David's personality. In the end, I housed the photos and invitation in an old cigar box. I like the antiqued gold detailing and the fact that it could be hung from a simple cup hook when open. The leaves at the bottom hint at his interest in preserving the rain forest.

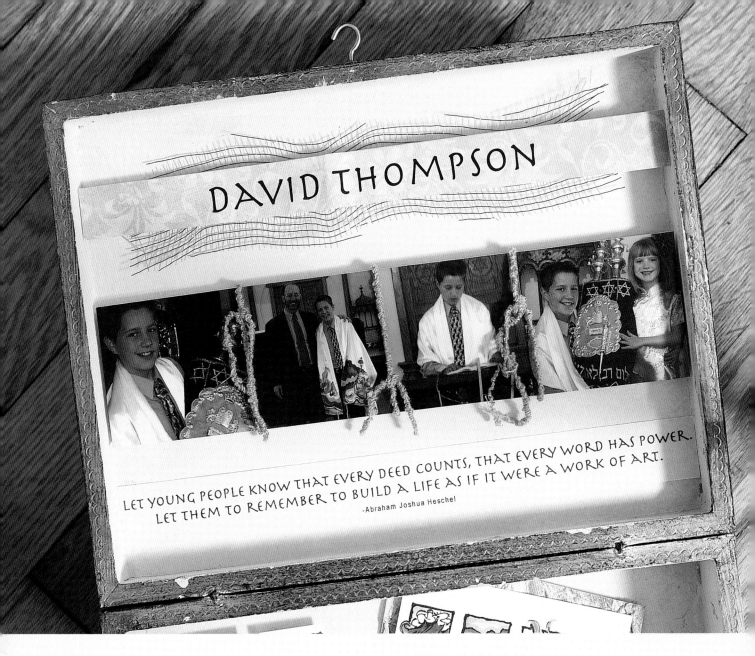

DAVID THOMPSON

LET YOUNG PEOPLE KNOW THAT EVERY DEED COUNTS, THAT EVERY WORD HAS POWER. LET THEM TO REMEMBER TO BUILD A LIFE AS IF IT WERE A WORK OF ART.

-Abraham Joshua Heschel

What You Need

Colored vellum

Scissors

Old cigar box

Soft floral-patterned paper

Foam core

Spray adhesive or other adhesive of your choice

Photos

Wrapping ribbon

Yarn

Glue gun and hot glue

Invitation

Adhesive-backed foam-core dots

Industrial adhesive

Star-of-David charm

Leather texture paper

Scrapbooking paper for leaves

Spray paint

Mini-envelope

Cup hook

Craft felt cut into small squares

What You Do

1. Find an appropriate quote and print it out on vellum, making sure that the size is readable and will fit in the box you intend to use. Print out the name of the recipient on patterned floral paper, again using a font size that's large enough to read from some distance. Cut a piece of foam core to fit inside the box, and trim the name to the size of the foam core. Adhere the name to the foam core with spray adhesive. Cut a

piece of wrapping ribbon to the length of the box, then adhere it to the back of the name. Attach the ribbon to the box with hot glue.

2. Crop the photos and mount them on a foam-core rectangle that fits the length of the box. Wrap yarn around the piece to create borders between the photos. Attach the quote and photo montage to the box with spray adhesive.

3. Trim elements from an extra invitation (here there are four elements from the invitation artwork). Adhere the elements to the box with adhesive-backed foam-core dots. Attach the Star-of-David charm below the invitation elements.

4. Attach the invitation to a piece of leather-textured paper and adhere it to the box. Add a photo over part of the invitation, using industrial adhesive.

5. Cut leaves from scrapbook paper and spray paint them. I attached the leaves over the invitation with hot glue and added the mini-envelope over the leaves. Then I tucked the bar mitzvah newsletter announcement inside it.

6. Add a screw-in cup hook at the top of the box so that it can be displayed open. If you like, attach small felt squares to the bottom of the box to prevent wall scratches.

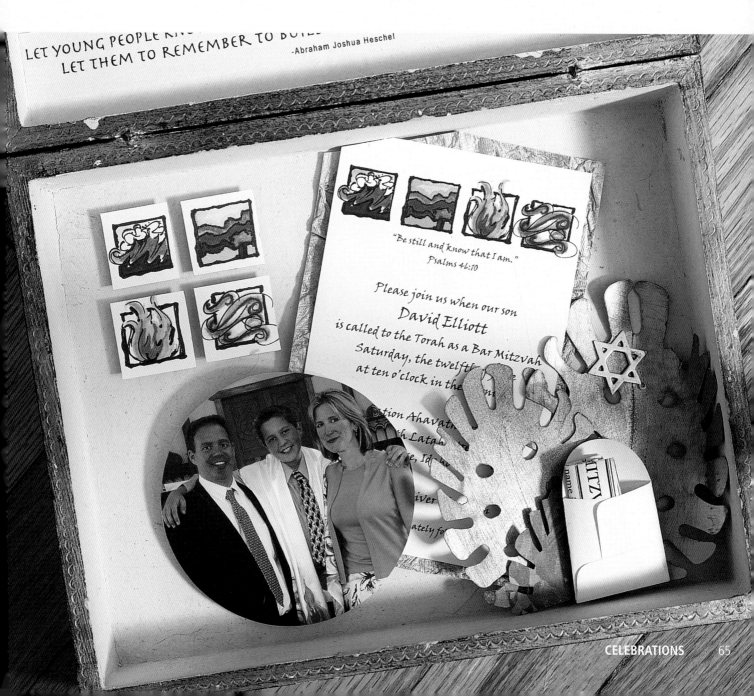

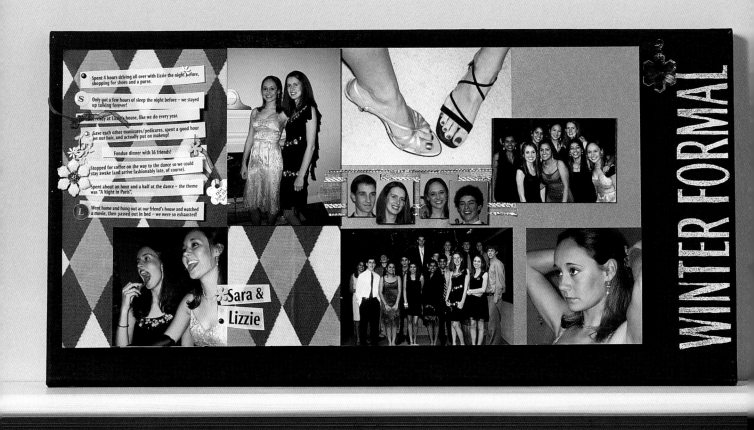

Spent 4 hours driving all over with Lizzie the night before, shopping for shoes and a purse.

Only got a few hours of sleep the night before – we stayed up talking forever!

Got ready at Lizzie's house, like we do every year.

Gave each other manicures/pedicures, spent a good hour on our hair, and actually put on makeup!

Fondue dinner with 16 friends!

Stopped for coffee on the way to the dance so we could stay awake (and arrive fashionably late, of course).

Spent about an hour and a half at the dance – the theme was "A Night in Paris".

Went home and hung out at our friend's house and watched a movie, then passed out in bed – we were so exhausted!

Sara & Lizzie

WINTER FORMAL

In just a year, she'll be going off to college. A remembrance of a special night—like this piece focusing on a junior-year winter formal—will be even more meaningful when she's away from old friends. Getting ready for a dance is a big part of the fun. This layout focuses on two friends as they do their hair, put on makeup, and show off their pedicures before going out. Other details, like a sprinkling of glitter and a glass snowflake, emphasize the glitzy, dazzling feeling of the event.

What You Need

12 x 24-inch (30.5 x 61 cm) pre-stretched canvas

Black acrylic paint

Paintbrush

Letter stencil

Pencil

White acrylic paint

Red shake-on glitter

Scissors

Heavy black mat board

Solid and patterned scrapbooking papers

Spray adhesive

Vellum

Scrapbooking odds and ends (eyelets, brads, letter sticker, ribbon)

Assorted ribbons

Hole punch (optional)

Photos

Craft glue

Snowflake glass prism and wire

Scrap cardboard

Industrial adhesive or hot glue

What You Do

1. Paint the canvas black with acrylic paint. Wait for the paint to dry completely, then trace the name of the event onto the canvas and paint on the words in white. Sprinkle a little red glitter around the area.

2. Cut a piece of mat board and cover it with scrapbook paper in patterns or solids. Attach the paper to the board with spray adhesive.

3. Print some of the highlights of the event on vellum. Cut them out and attach the strips to the mat board with brads, stickers, charms, or ribbons threaded through punched holes.

4. Attach the photos to the mat board with craft glue, mounting some of your favorites on smaller pieces of mat board first to make them stand out. Add some ribbon behind smaller photos for extra texture.

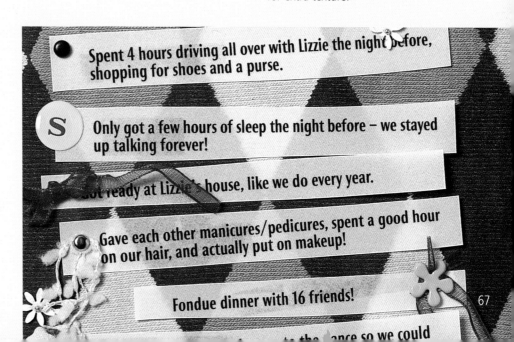

Spent 4 hours driving all over with Lizzie the night before, shopping for shoes and a purse.

S Only got a few hours of sleep the night before – we stayed up talking forever!

...ot ready at Lizzie's house, like we do every year.

Gave each other manicures/pedicures, spent a good hour on our hair, and actually put on makeup!

Fondue dinner with 16 friends!

...the dance so we could

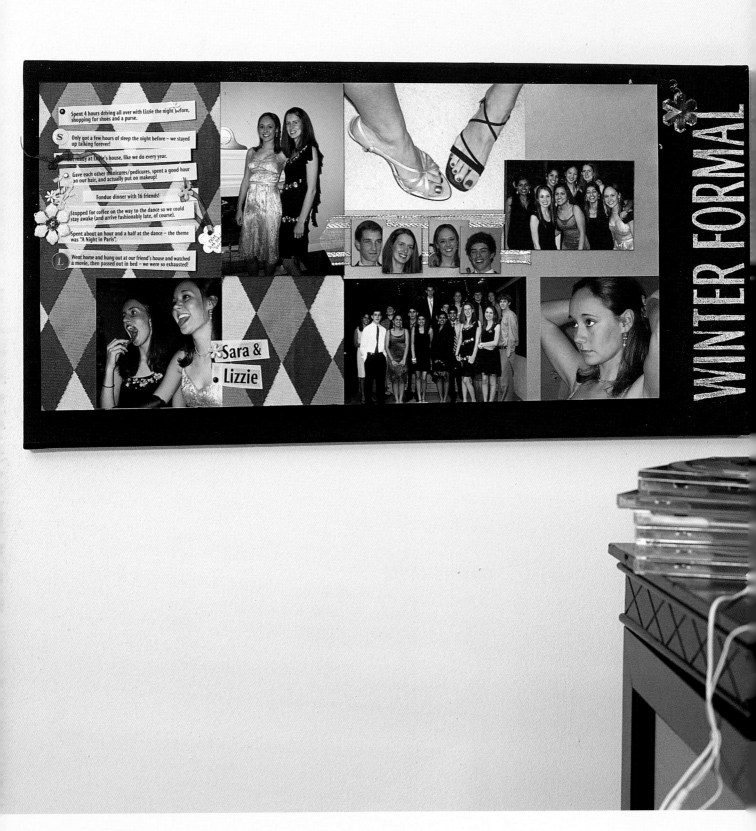

- Spent 4 hours driving all over with Lizzie the night before, shopping for shoes and a purse.
- Only got a few hours of sleep the night before – we stayed up talking forever!
- Got ready at Lizzie's house, like we do every year.
- Gave each other manicures/pedicures, spent a good hour on our hair, and actually put on makeup!
- Fondue dinner with 16 friends!
- Stopped for coffee on the way to the dance so we could stay awake (and arrive fashionably late, of course).
- Spent about an hour and a half at the dance – the theme was "A Night in Paris".
- Went home and hung out at our friend's house and watched a movie, then passed out in bed – we were so exhausted!

Sara & Lizzie

WINTER FORMAL

5. Punch a hole in the canvas for the snowflake's wire. Curl the wire and attach the snowflake.

6. Attach thick cardboard to the back of the mat-board piece (for height) and adhere the cardboard to the canvas with industrial adhesive or hot glue.

Variation

• Add a dried corsage or party favor to the display.

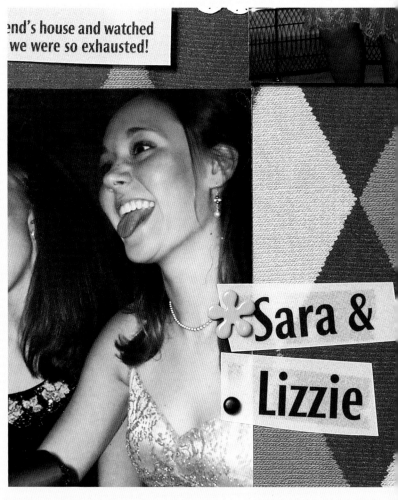

Love is in the Air

Every year I host a handmade valentine-making party—a great wintertime break and a fun excuse to get friends together to cut and paste valentines and to drink mimosas. I love to use quotes in my valentines, so I wrote some of them around the edge of this frame. I've also included the invitation, some sample valentines, candy hearts, and a feather-winged heart. You could adapt this idea to commemorate any holiday tradition.

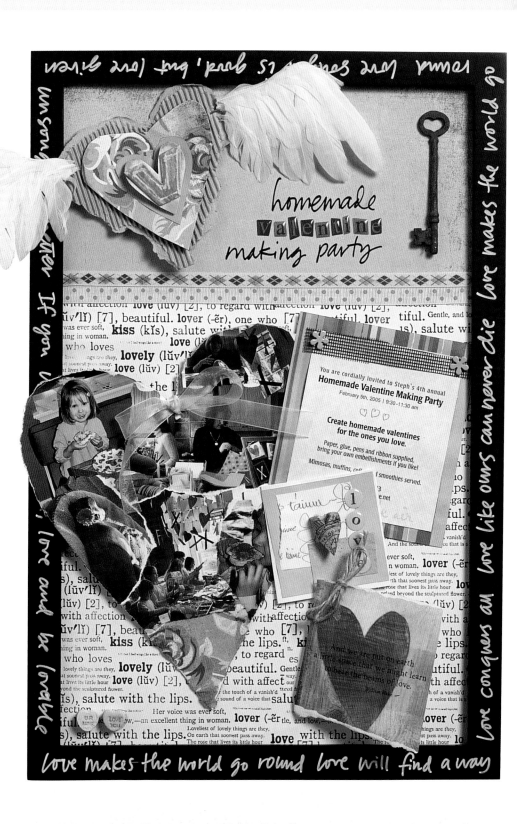

homemade valentine making party

What You Need

Photos

Card stock

Decoupage medium

Hole punch

Ribbons

Scrapbooking paper

Adhesive of your choice

12 x 18-inch (30.5 x 45.7 cm) black
 frame

Invitation and holiday ephemera

Corrugated cardboard, scrapbooking
 papers, feathers, and letter stickers

Rusty key (optional)

Industrial adhesive (optional)

Spray paint or acrylic paint

White and black paint pens

What You Do

1. Create a photo collage by decoupaging photocopied photos onto a piece of card stock. Tear the paper into a heart shape, punch a hole near the top, and thread ribbon through the hole for more dimension.

2. Adhere two different patterned papers to the frame's mat. Add ribbons as a border between the different papers.

3. Adhere the collage, invitations, and holiday-theme ephemera on top of the layout. I added valentine candy hearts and examples of the valentines made at the party. For the top of the display, I created a layered heart with corrugated cardboard, scrap paper, and feathers. I adhered it and the rusty key (note the heart shape!) to the layout with industrial adhesive.

4. I wrote the title of the party on the background paper in black marker and added pebble-letter stickers for more dimension.

5. Write quotes or memories around the edge of the frame with a white paint pen.

Variations

• This display could also work mounted on a few old pickets from a fence or wired to a small gate door.

• Consider using a contrasting color, or one you wouldn't expect for your layout. A black and white paper is a background here, but a solid green or chocolate brown (not just pink and red) could emphasize the valentines in a different way.

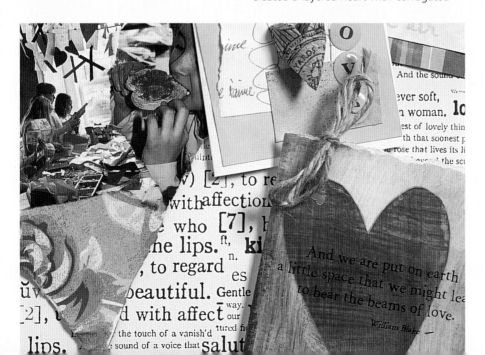

Boo Bash

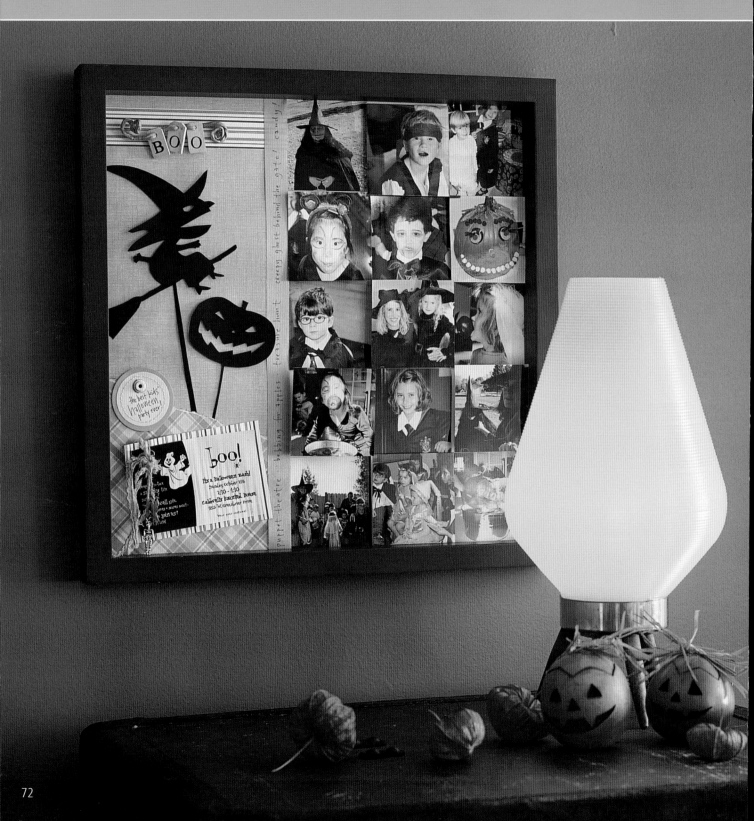

This had to be the best kid's Halloween party ever—a scavenger hunt, bobbing for apples, crafts, a puppet theatre, scary witches, and endless candy. My friends raised the bar. I couldn't show everything, so I let the photos do the work in a cubed patchwork of three different heights. I loved the darling puppet theatre characters, too, so I cut them out of heavy black paper. They steal the show.

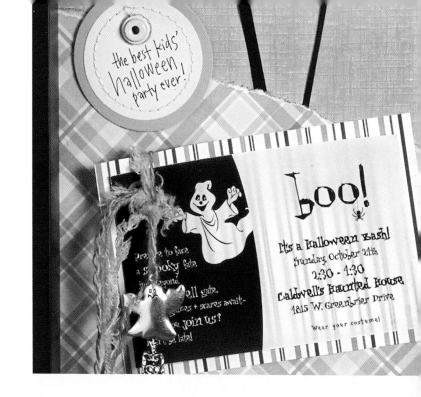

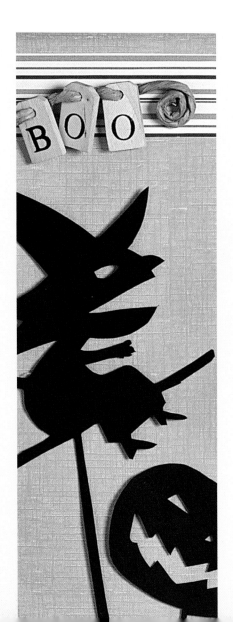

What You Need

24-inch (61 cm) square wooden frame
Foam core or cardboard
Scissors
Pack of scrapbooking materials including coordinating papers, eyelets, tags, and yarn
Party invitation
Charm (hanging off invitation)
Spray adhesive
Heavy paper
Photos
Old-fashioned hand-puppet illustrations
Tracing paper
Heavy black paper (available at art stores)
Florist wire
Wooden scrapbooking letters with predrilled holes
Jewelry pliers
Glue gun and hot glue or industrial adhesive
Florist ribbon
Paint pen

What You Do

1. Cut foam core or cardboard to the frame size for a base.

2. Attach the eyelet and tag to the scrapbook papers, then attach the papers to the base with spray adhesive. Attach the party invitation over the papers and add a charm to it.

3. Mount the photos to heavy paper, then crop to consistent square shapes.

4. Attach the photos to the background. Attach some of the photos to foam core to create an alternating raised-flat pattern.

5. Scan the puppet illustrations and print them to size. Trace them with white tracing paper onto black paper. Trim and attach them just below your accent papers.

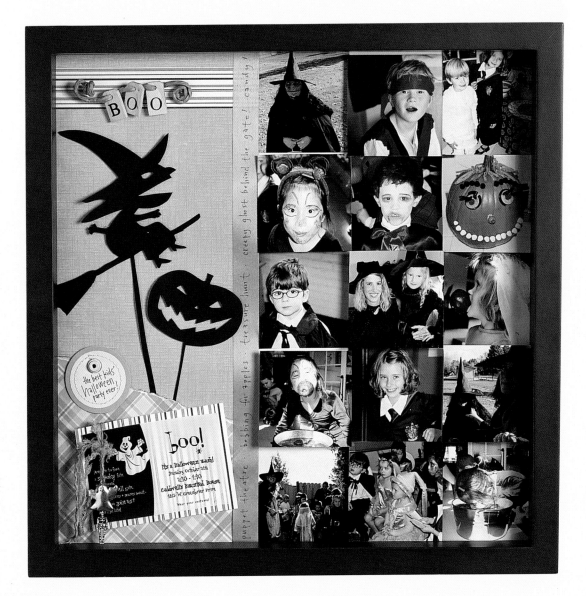

6. Thread the wooden letters with florist wire, and curl the ends of the florist wire with jewelry pliers. Attach a patterned paper on the background paper and adhere the wire to it with hot glue or industrial adhesive.

7. Hand write words on the floral ribbon and attach it to the display.

Variations

• *Tip:* Leave extra room on edge photos of display. That way the photos can be tucked under the frame's edge.

• Consider painting words along the frame.

• This idea of a raised cubed patchwork of photos can be used for almost any layout.

Birthday Boys

This cheerful project celebrates the third birthday of some adorable triplets, but you could adapt it for a single child or twins. Gumballs add a fun, colorful detail to this cheerful display. A simple, thin canvas can be painted to coordinate with any room, and the easel makes the display more unique.

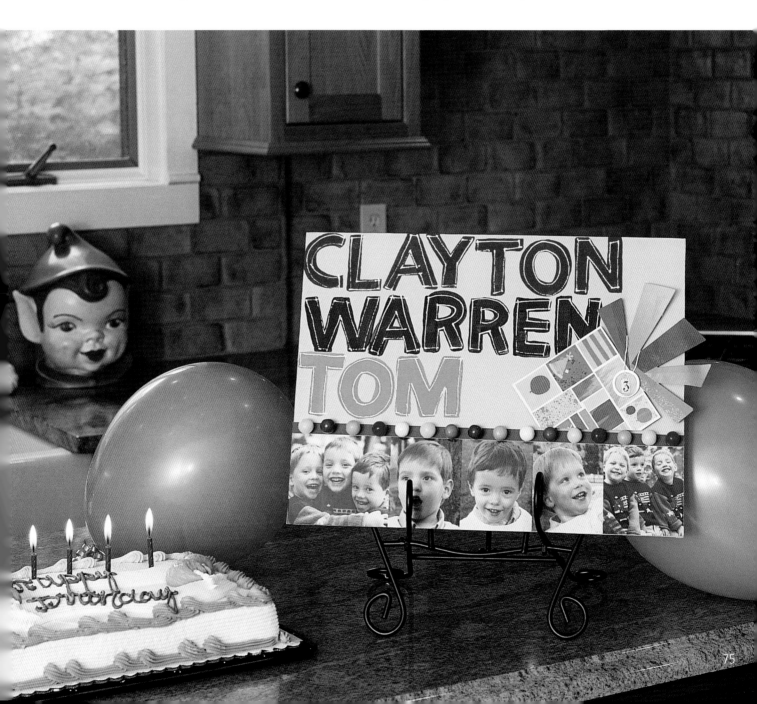

What You Need

12 x 16-inch (30.5 x 41 cm) pre-stretched canvas
Acrylic paint
Paintbrush
White paint pen
Photos
Adhesive of your choice
Scissors
Thin strip of mat board
Gumballs
Glue gun and glue sticks
Illustrated gift bag (the present illustration was torn off a gift bag)
Foam core
Clear circle tag
Easel

What You Do

1. Paint the canvas (I used extra house paint I had around).

2. Paint the child or children's names in acrylic paint, then draw inside letters with a white paint pen.

3. Crop your photos and adhere them to the bottom of the canvas (I scanned these photos, cropped them, and printed the photo strip on card stock).

4. Cut a strip of mat board (I liked the contrast of a non-colorful brown) and adhere it to the canvas. Hot glue gumballs in a line (mine are spaced 1 inch [2.5 cm] apart) on top of the mat board.

5. Use an applied decoration from a gift bag (I used a present illustration) and trim it to fit your layout. Attach foam core bits on the back of it for height and adhere it to the layout. Complete the layout with a clear tag, and write the age of the child on it.

6. Display the canvas on an easel.

Variations

• Look at the bottom of gift bags for graphics you can use—the different angles and colors coming together can make a great background.

• If you're making this project for twins or triplets, you could create duplicate projects using the same photos, and change the colors for each sibling's room.

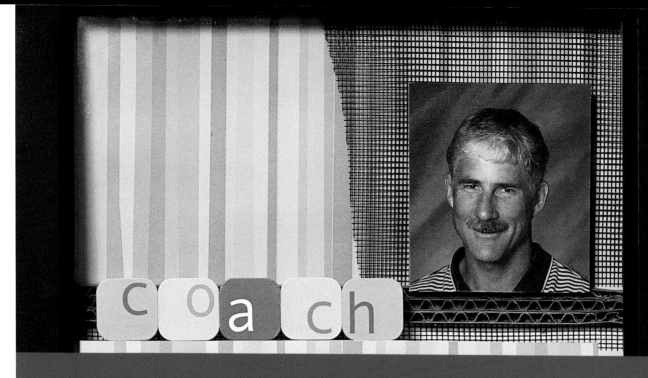

Coach

Do What You Love

Sports, hobbies, art—what are you and your family passionate about? Celebrate your favorite pursuits with the fun and inventive projects in this section. Wondering what to do with all the medals and ribbons your kids have racked up from competition? Check out the bike racing, gymnastics, and gourd projects in the following pages. Want to thank a great coach for his or her efforts? The "Thanks, Coach" display is a thoughtful gift idea. These project ideas capture what's most fun about your favorite pastimes.

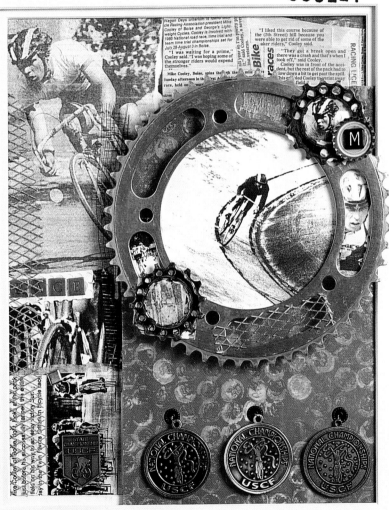

Mike is a competitive cyclist and owns a popular bike shop in my town—no way did I want this project to look cutesy. I created a collage of memories—the motion in the swirling track photo behind the metal disc perfectly captures the energy of bike racing. This idea could very easily be transferred to other hobbies or pursuits—think of found-object elements associated with the hobby that can be added for dimension.

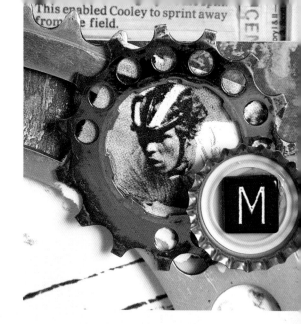

What You Need

16 x 20-inch (40.6 x 50.8-cm) frame with mat
Photocopied photos, newspaper clippings
Scissors
Mat board
Spray adhesive
Decoupage medium
Acrylic paint
Paintbrush
Clear tape
Scrapbooking letters, metallic and press-on
Scrapbooking snaps
Ribbon

Scrapbooking paper
Racing medals
Bike parts, including chain and metal discs
Bottle cap
Industrial adhesive
Foam core
Pieces cut from aluminum gutter protector*
Letter stencils
Felt-tip marker

*Available at home improvement centers

What You Do

1. Photocopy photos and articles and mount them on the frame's back mat or on a piece of mat board, using spray adhesive or any other adhesive that works for you. For some of the articles, I used decoupage medium and then applied a wash of silver paint over the top. I also applied some of the photocopies with clear tape.

2. Attach metallic letters, snaps, and ribbon on top of the copies as desired.

3. To make the three-dimensional addition to the display, cut a piece of mat board to the desired size and shape and cover it with patterned scrapbooking paper. Attach racing medals to the piece with snaps. Cut additional pictures to fit inside the bike parts. Attach a bottle cap to one of the bike parts with industrial adhesive. Attach the bike part to a round piece of foam core with industrial adhesive, then attach the foam core to the mat-board piece.

4. Attach the mat-board piece to another piece of foam core before attaching it on top of the photocopies. Before sliding the whole display into a frame, attach a little of the gutter protector to the top.

5. I used scrapbooking press-on letters to add lettering to the outer mat. Attach some bike chain to the outer mat with industrial adhesive.

A Real Champ

Kids put so much effort into sports and hobbies. This kind of display is a great way to celebrate their successes. Chloe says brown is for clothes and horses, not gymnastics, so I used bright colors on this project, layering Chloe's gymnastics ribbons on the color copier and having large copies made. The salvage metal hardware acts as its own type of parallel bar. The white packing fabric symbolizes my wish for many safe landings.

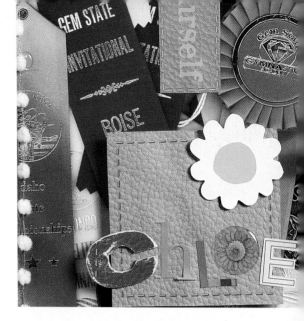

What You Need

Photocopied photos, medals, and ribbons
White packing fabric
17-inch (43 cm) square shadow box
Scrapbooking letters, plastic flowers, stickers, and brads
Spray adhesive or craft glue
Mat board
Metal photo corners
Wire or twine
Salvage metal hardware
Industrial adhesive
Foam core
White pom-pom ribbon
Stencil and marker or stamps and ink

What You Do

1. Bend the corner of the white packing fabric and attach it to the background mat with a brad, then glue the background mat in place in the frame.

2. Arrange the ribbons and medals on a color copier, and copy on the 11 x 17-inch (48 x 43 cm) setting. Adhere to a piece of mat board and attatch both to the layout. Add metal photo corners to the photos.

3. Adhere the photos to a piece of mat board that's been cut to fit in the frame. Add metal photo edges to the photos.

4. Hang a piece of wire or twine from the metal object, and attach a scrapbook-paper saying on the wire. Adhere the metal piece over the photos with industrial adhesive.

5. Create the child's name with random letter stickers and paper cutouts. Adhere the name to a paper square, then mount the square on foam core for height.

6. Finish the edge of the large photo collage by adhering pom-pom ribbon trim to its edge.

7. Stencil or stamp the name of the sport onto the mat board.

Variations

• A mini photo album could be mounted to the background, filled with special photos inside.

• The edge of the frame could be decorated with repeating glued flowers, medals glued to the edge, or a collection of handwritten encouraging words.

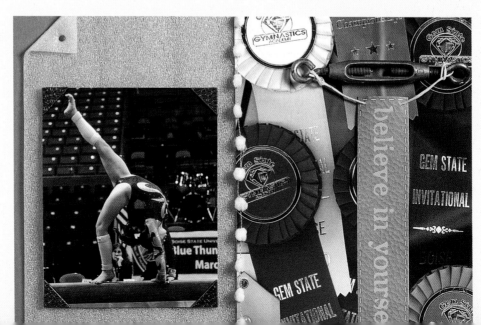

Best in Show

Gourds. My mom grows them, paints them, and sells them. Her gourd booth was voted Best in Show at an art festival, and I wanted to help her show off the ribbon. I used a lot of red—her favorite color—and created a background of broken gourds with scattered photos around the edge. The sticker with the number 11 on the ribbon represents the number of dollars she made at the show. It's not always a profitable hobby, but hey, it's still great to be recognized with an award.

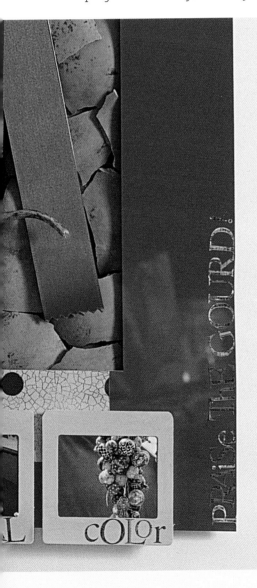

What You Need

Prize ribbon
Foam core
Craft paper
Spray adhesive
Cardboard
Glue gun and hot glue
Mat board
Photos
Scrapbooking slide photo frames
Scrapbooking sticker letters
Sandpaper
24 x 36-inch (61 x 91 cm) shadow box frame

What You Do

1. Mount the ribbon on several layers of foam core.

2. Adhere craft paper to the background cardboard with spray adhesive. I broke dried gourds and hot glued them over the craft paper, then glued the ribbon on top of them.

3. Cut the mat board to create a frame to go around the ribbon display.

4. Attach the photos in slide frames and attach sticker letters to the edge. Sand the edges of the slide frames for an aged look.

5. Attach the display to the back mat of the frame.

Variations

• For an interesting texture you can cover the background with just about anything—coffee beans, seashells, matchbox cards, baby shoes—whatever makes sense with your display.

• Use just your favorite photos (edit, edit, edit).

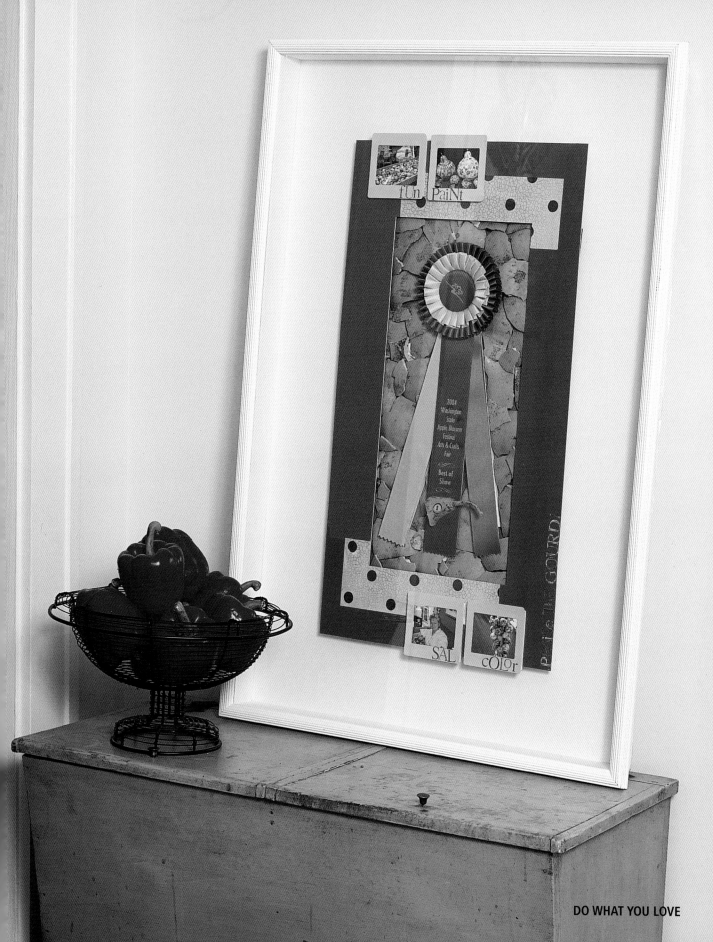

Thanks, Coach

This gift is a great way to thank a coach for his or her hard work and inspiration. I included Coach Unger's photo and some strips of cardboard and window-screen mesh for funky texture. On the outside of the glass lid, I added stickers and the name of the team. The combination of elements inside and outside of the box gave the piece added interest.

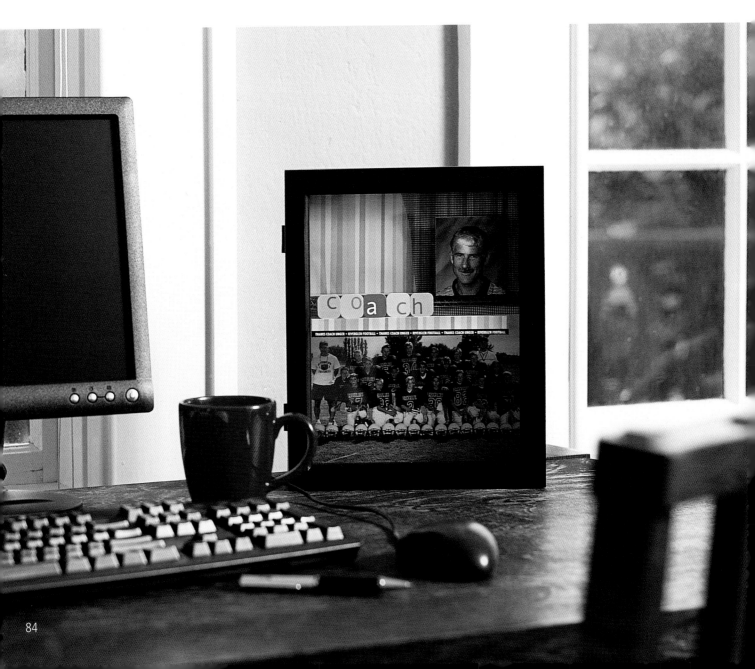

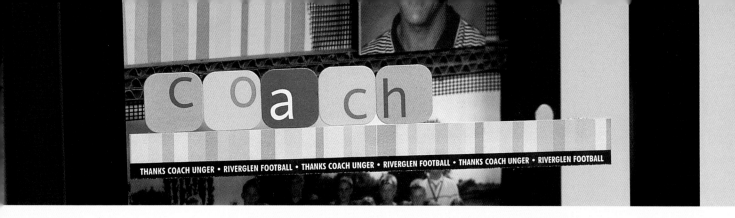

What You Need

8 x 10-inch (20.3 x 25.4-cm)
 shadow box
Patterned scrapbooking paper
Photocopied photos
Scissors
Archival glue
Window-screen mesh
Cardboard cut into skinny strips
Foam core
Small pieces of card stock
Spray adhesive
Craft glue
Letter stickers

What You Do

1. Arrange the patterned scrapbooking paper and team photo, cutting them as necessary to fit in the shadow box. Attach them to the bottom of the shadow box with the archival glue of your choice.

2. Add window-screen mesh and cardboard strips over the pieces you just attached. I added a little mesh first over the patterned paper on the upper part of the display, then added the cardboard strips to separate the upper (patterned paper) and lower (team photo) parts of the display. I let a little of the mesh appear under the cardboard strip to unify the piece.

3. Mount the coach's photo on a piece of card stock using spray adhesive, then adhere the back of the card stock to another piece of card stock cut to fit it. Attach the foam core to a piece of cardboard and adhere it over the patterned paper.

4. Print "Thanks" and the school name, trim and paste to a small piece of patterned scrapbooking paper. Attach the piece to the glass with glue.

5. Add letter stickers to spell out "coach."

Variations

- Create a small shelf to hold a trophy inside a larger shadow box.

- Have team members sign the mat or paper surrounding the team photos.

- Include any newspaper stats, articles, or team scores (winning or losing!).

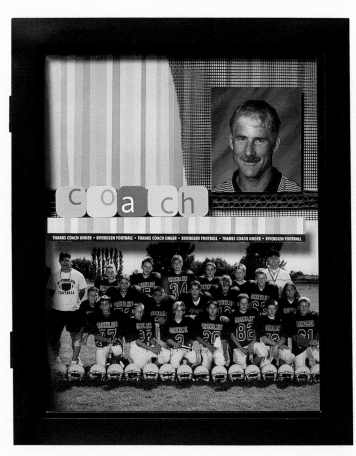

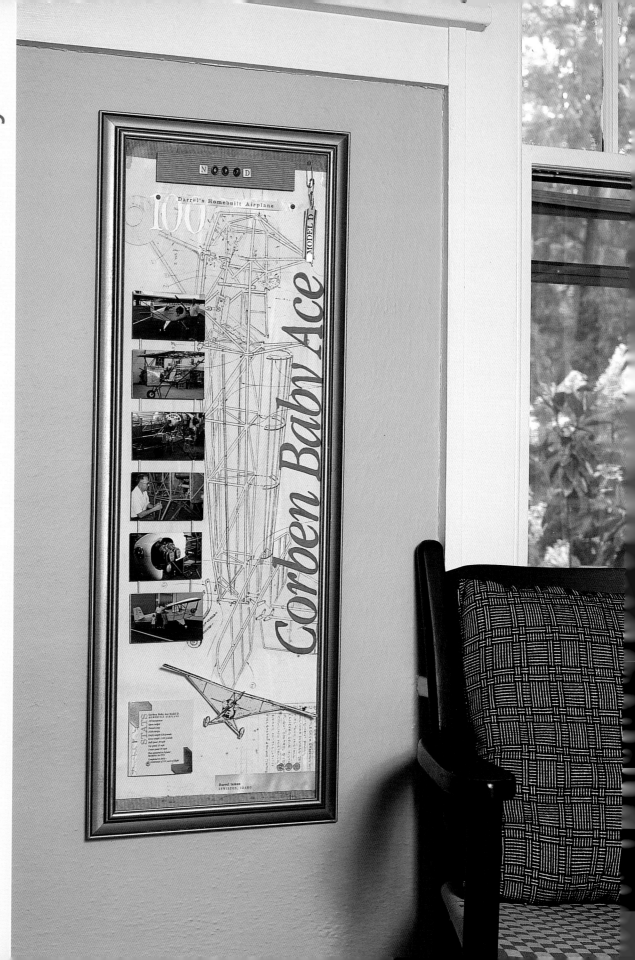

Building an airplane from plans was one of my dad's hobbies for several years. He built everything from scratch on this open cockpit, one-seater airplane—the Corben Baby Ace. The large "100" refers to the plane's 100 horsepower and 100 years of flight—it was completed in 2003, which was the centennial of the Wright brother's first flight. This project could be adapted for any building project.

What You Need

Photocopied working drawings or blueprints
Spray adhesive
Foam core
Acrylic paint
Tea for stain
Project drawing
Khaki-colored paper
Clip art (optional)
Card stock
Scissors
Eyelet (optional)
Glue gun and hot glue
Pencil
White paint pen
Textured vellum
Decoupage medium
Scrapbooking stickers
Cashier keys
Scrapbooking papers
Corrugated cardboard
Wire
Safety pins
Mesh screening
Part of a map
Metal framing corners
Wooden skewers
Photos
24 x 36-inch (61 x 92 cm) frame

What You Do

1. Make an oversized copy of the working drawings, and spray mount the piece to foam core. Antique the paper with a mix of strong tea and brown acrylic paint mixed with water.

2. Scan a drawing of the completed project and print it to size on khaki paper. I chose a front view of the plane and added a clip art squirrel to the wing because my dad said the plane was "a bit squirrelly" the first time he flew it. Mount the paper on card stock and trim around the edges. I added an eyelet to attach the propeller. Mount the piece at an angle from the background with small strips of foam core attached with hot glue.

3. Print the title and trace it onto the background piece. Color in the letters with acrylic paint and highlight the edges with pencil. I did the same with the number '100' but used white ink.

4. Print a small title on textured vellum and decoupage that to the background, adding rusty-looking screw stickers at the edges. I added the plane's call numbers in letter charms and old cash register keys (slipped through slits cut in the cardboard and hot glued in the back) to corrugated paper and attached it to foam core. The model name was added with wire and safety pins.

5. Add a bit of mesh screen (the kind you'd use for a screen door) on both edges of the display.

STATS

Corben Baby Ace Model D
HOMEBUILT AIRPLANE
100 horsepower
Open cockpit
Parasol wing
1920s design
Empty weight: 620 pounds
Gross weight: 1,000 pounds
Stall speed: 39 mph
Top speed: 95 mph
Cruise speed: 85 mph
Plan appeared in Popular Mechanics in 1955
Completed in 2003 – Centennial of 100 years of flight

6. I printed the "stats" of the plane on an antiqued paper and added a strip of a map to the edge, then attached metal photo corners on two sides. I mounted the piece on foam core for height.

7. I added wooden skewers on top of the background, then attached photos of my dad and the plane to foam core and hot glued them onto the skewers. The skewers reminded me of the skeletal frame of the plane.

Variations

• A fun variation would have been to have a banner hanging behind the plane, or my dad's face in one of the drawings of the cockpit.

• Try different ways of antiquing papers—walnut ink, diluted wood stain, or brown and yellow pastels.

Team Spirit

In our busy grown-up lives, there's often not much time to just hang out and have fun with friends. That's why adult sports teams are really something to celebrate. At The Beehive, the salon where I get my hair cut, the women are fun and wild. They love pink and they love their salon softball team. This collage uses bits trimmed from their salon menu and business cards as layout elements. Since the layout is kind of busy, the wide, white mat gives the eye a resting place. This idea can be adapted for any grown-up team.

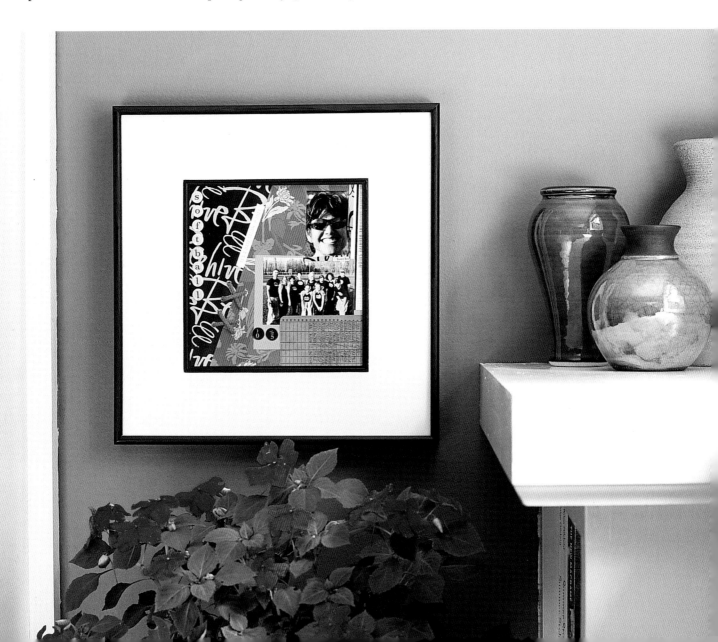

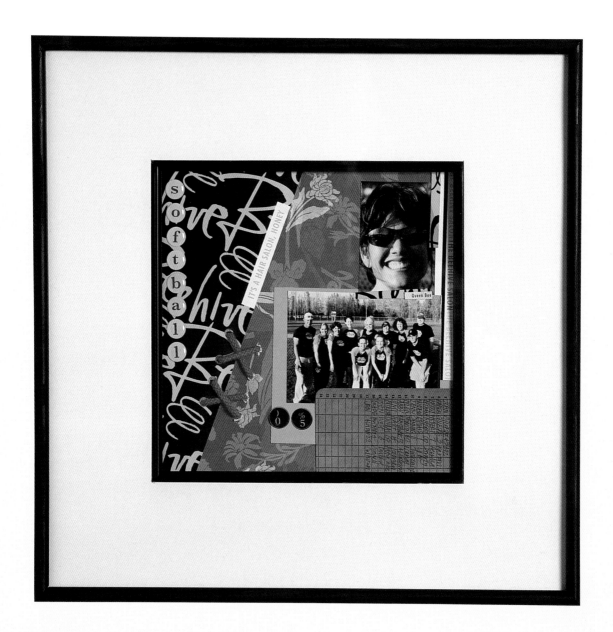

What You Need

Scrapbooking papers and stickers
Scissors
Craft glue or spray adhesive
**14-inch-square (35.6 cm) frame
 with mat**
Hole punch
Cord or shoelace
**Business cards or other printed
 material that relates to the
 team's sponsor**
Photos
Lined paper
Pencil

What You Do

1. Arrange your scrapbooking papers the way you want them. The key to this layout is positioning the scrapbooking paper at an angle. Adhere them to the back mat of the frame with spray adhesive or craft glue.

2. Hole punch through the scrapbooking papers and lace the cord through to look like shoelaces. Add stickers if desired.

3. Attach the photos, business cards, and other ephemera over the scrapbook paper with craft glue or spray adhesive.

4. Create a team "roster" on lined paper or on an old scorecard.

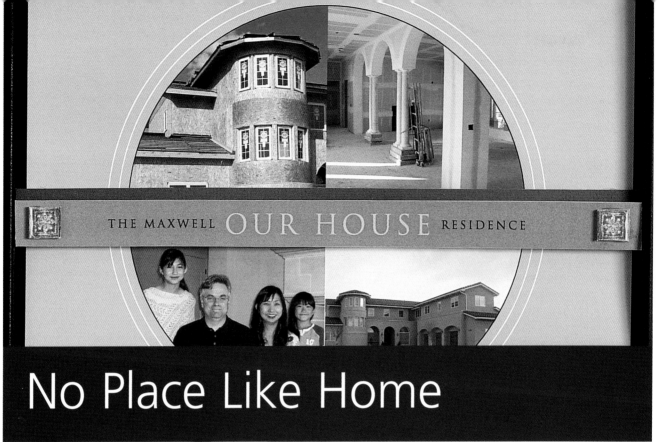

THE MAXWELL OUR HOUSE RESIDENCE

No Place Like Home

Home sweet home. For many, a home is a project in itself, the subject of constant renovations and rejuvenations. The pieces in this section show you some inventive ways to document progress on household endeavors or even create housewarming gifts or functional objects. Use a home's distinctive characteristics—a wallpaper pattern, tile design, or architectural feature—as the jumping off point for a layout that celebrates a new home or the completion of a garden project. Create a tote to carry things to and from a second home. Use these ideas to spark your imagination and come up with original ideas.

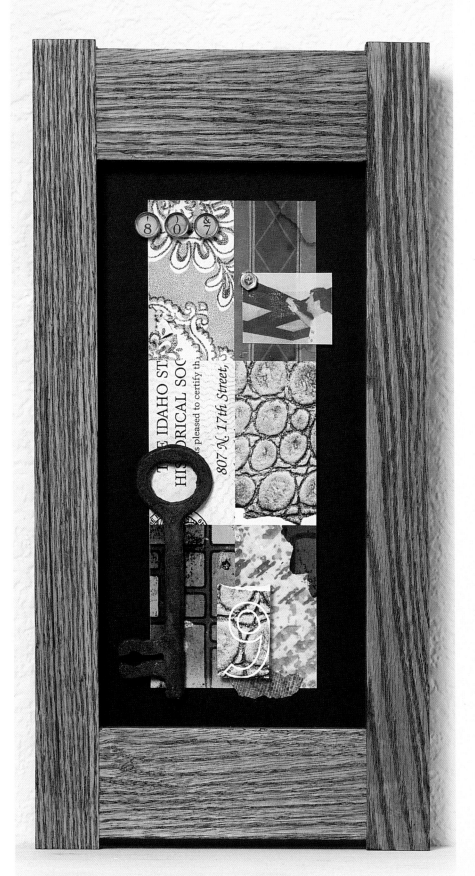

This Old House

Restoring an old home is a labor of love, full of challenges and surprises. While restoring their craftsman-style bungalow, Ashley and Gary found nine layers of wallpaper in one room and hidden coffered ceilings in another. To document their project and their home's inclusion into the Idaho Historic Register, I created a special piece for them. I scanned the found linoleum, wallpaper bits, and their historic register certificate to create a grid, enlarging a few patterns for a more modern effect.

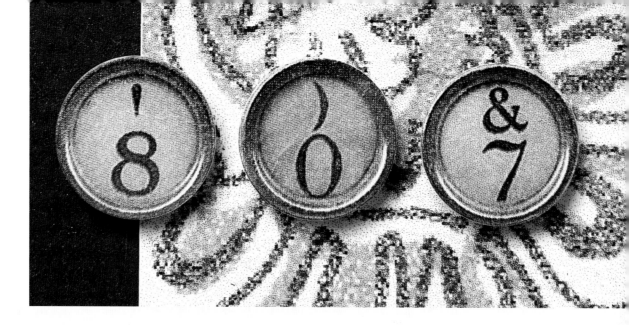

What You Need

Scanned images of documents, linoleum, wallpaper, photographs

Color printer

Scissors

Black mat board

Spray adhesive

Adhesive-backed foam core

Large, rusty key

Industrial adhesive

Small screw

Scrapbooking stickers

Oak frame (this one was custom made, but you can use an attractive purchased frame with a handmade look)

Strong, clear packing tape

Frame hardware

What You Do

1. Scan the texture (wallpaper, linoleum, etc.) images, photos, and documents you want to use for the piece. Arrange them in a grid pattern. Print them out and adhere them to the mat board.

2. Cut the mat board to fit in your frame. (Because the Arts and Crafts Movement placed a significant emphasis on hand craftsmanship, I asked my dad to create a simple oak frame just for this project).
If your frame doesn't have closures on the back, you can adhere the mat board to the frame with packing tape.

3. Print one of the numbers of the street address over one of the scanned patterns. Tear the edge of the paper and stick it on a piece of adhesive-backed foam core, then adhere the foam core over the patterned printout in the position of your choice.

4. Adhere the key over the piece with industrial adhesive.

5. Attach a scanned photo over the patterned paper with spray adhesive. Use industrial adhesive to add a screw over one corner of the photo to make it look as though the screw is holding the photo in place.

6. Attach number stickers to adhesive-backed foam-core dots to add the whole street address to the piece, then adhere the dots over the patterned-paper print-out.

Variations

• Consider adding the house numbers or house owner's names to the frame.

• Add more found materials—screws, linoleum, or hardware pieces—in and around the background grid.

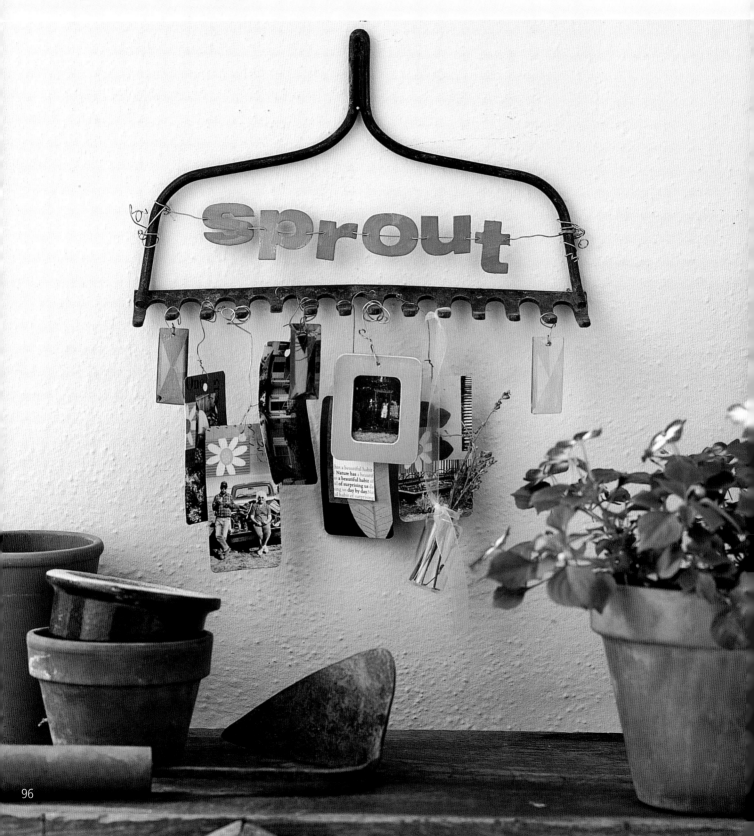

A garden is an ever-changing, ever-growing work of art. I think of this project as a grown-up mobile that celebrates a gardener's hard work. This display focuses on my friend Linda, who transformed her backyard, creating raised beds, an arbor, and even a pond. Luckily much of her work was photo documented! This fun, earthy accent would look great hanging in a garden shed.

What You Need

Scanned photos
Decoupage medium
Greeting cards
Pre-cut scrapbooking tags
Small wooden frames
Acrylic paint
Paintbrush
Slate gardening stakes
Cardboard scrapbooking letters
Hole punch
Rusty rake end
Wire in different gauges
Faux jewels
Mini-vase of dried lavender

What You Do

1. Decoupage scanned photos and greeting-card bits onto premade tags or mount them in small wooden frames.

2. Decorate your gardening stakes by painting garden-related words, such as "bloom," on them.

3. Paint the cardboard letters green. When they're dry, punch holes in them to thread the wire through and attach them to the rake end.

4. Attach the tags, jewels, and vase to the rake prongs with wire.

Variations

• To make the piece more suitable for an outdoor environment, laminate the tags and brush a coat of polyurethane over the cardboard letters.

• Consider using a similar design with a wooden-peg coat rack instead.

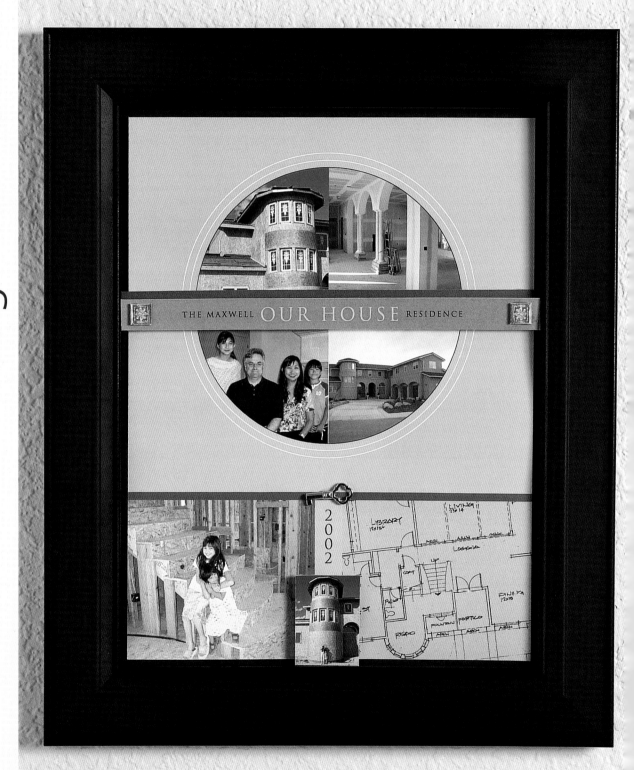

Building a new home is an exciting adventure. This display features photos, a bit of a floor plan sketch, and tiny tiles scanned from tiles from a custom-designed house project. I added the gold key for a little bit of sparkle in an otherwise traditional design.

What You Need

Scanned photos and images
Mat board
Foam core
Spray adhesive or adhesive of
your choice
Industrial adhesive
Key charm
14 x 17-inch (35 x 43 cm)
wood frame

What You Do

1. Use a graphics program on your computer for this first step. Scan your photos and arrange them in a circular grid pattern. Add a colored background behind the photos. Scan and arrange the floor plan sketch and black-and-white photo beneath the circular layout. Print the whole arrangement out on glossy paper. As an alternative, you can just arrange four photos and cut out a circular shape from mat board.

2. Mount a scanned photo of the house (or feature of the house) on a piece of foam core and adhere it to the display. Print out a title for your piece and then mount it on foam core and a piece of mat board before adhering it to the display.

3. Scan or photocopy an actual tile or other design element from the home's design and mount it as an accent on a piece of foam core. Attach it to the title strip.

4. Add a key at the place where the upper and lower sections of the display come together.

5. Mount the display in your frame.

Variations

• Look at what makes a home unique—the materials, the views, the site, the architecture—and try to incorporate in your layout.

• Consider adding materials found on site—nails, a little vial of soil, rocks around the frame.

• Journal stories about what went wrong and what went right.

The Weekend Getaway

This celebrates the vacation cabin that's near and dear to the Brisson family's hearts. I thought they could use the tote to carry things back and forth from home, but it might just happily stay on a hook in the hall as a conversation piece. Notice the "are we there yet?" detail at the top.

What You Need

Canvas tote bag
Iron-on printable transfer paper
Hole punch
Iron
Fabric paint
Scrapbooking eyelets and brads

What You Do

1. Print the photos of the home and words on iron-on paper. Apply the iron-ons to the tote according to the manufacturer's instructions. In this case, two sheets were trimmed and placed together to make the long strip at the bottom of the tote. Creating blocks can make matching the seam easier.

2. Use fabric paint to make an uneven painted edge at the bottom of the tote. (Mask one edge with masking tape when painting, then smear paint with your finger to make edge uneven.)

3. Transfer the iron-on onto another piece of canvas or fabric. Hole punch the fabric and insert copper-colored eyelets into the holes. Attach the fabric to the tote with brads.

Variations

- This idea could make a wonderful gift. If the homeowners emailed their house photos to you, you could print to iron-on transfer paper and make your own custom tote or an apron for a housewarming gift.

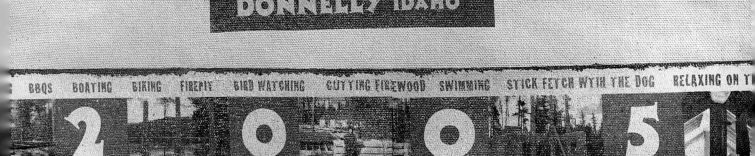

Nostalgia

Preserving family heritage is one of most important reasons for scrap-booking. In this section, you'll find ideas for making beautiful displays that you'll want to pass on to the next generation. Use your family's unique history as the inspiration for adding distinctive elements to a traditional family portrait treatment. Create a rustic-look family tree with found objects and materials and house it in an antiqued tray. Or show off a handmade object or cherished gift from a family member, letting your memories of the person who gave it to you guide your choices. These projects are made to have long-lasting impact.

Family Heritage

The five-year-old boy in the center of this photo (taken in the Czech Republic in 1905) is my mother-in-law's father. He came to America in his 30s and became, among other things, a skilled plaster worker. This project uses the photo, a map of the area he came from, plaster flowers created from soap molds, and handwritten remembrances to evoke the unique heritage of my mother-in-law's family. When adapting this project, think about your family's own story to bring in interesting elements.

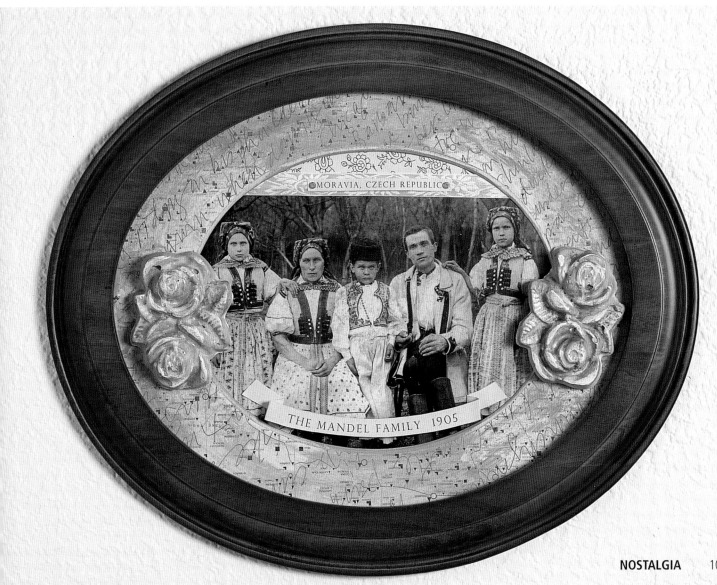

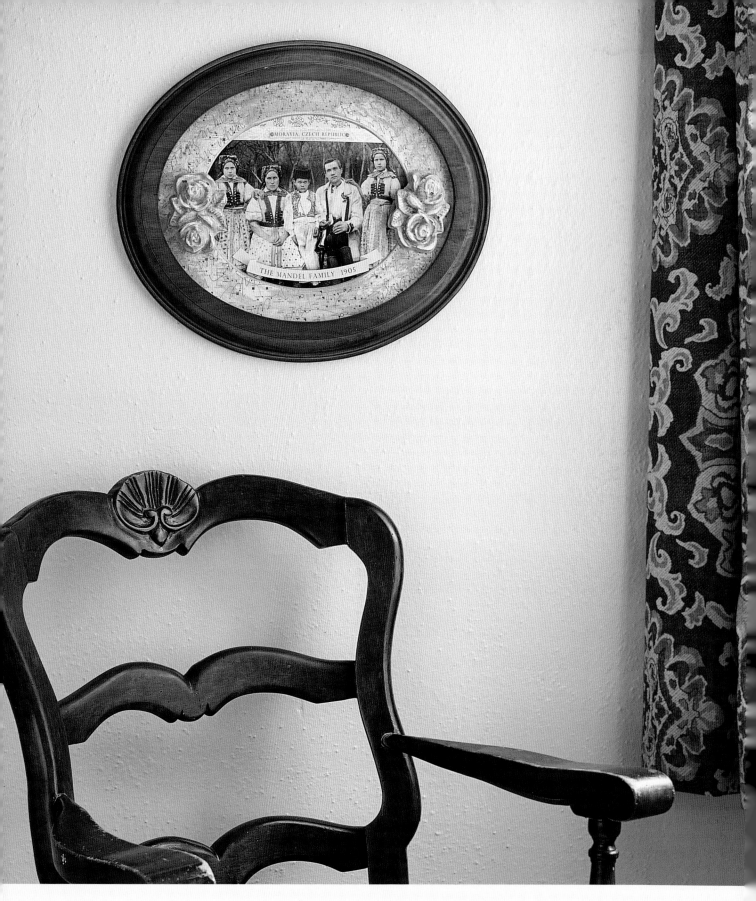

MORAVIA, CZECH REPUBLIC

THE MANDEL FAMILY 1905

THE MANDEL FAMILY 1905

What You Need

Map of area
Decoupage medium
Stained oval frame and oval mat
Acrylic paint
Paintbrush
Scissors
Clip art of floral pattern
Khaki-colored paper
Spray adhesive or other adhesive of
 your choice
White brocade ribbon
Eyelets
Family photo
Mat board
Foam-core dots
Archival adhesive
Flower soap molds
Plaster of Paris
Industrial adhesive
Wood stain gel
Cotton swabs

What You Do

1. Photocopy the area map and write notes on top of it. Decoupage it to the mat, then add a wash of paint over it (I used blue, my mother-in-law's favorite color).

2. On khaki-colored paper, print out a small title for the top and larger family name for the bottom.

3. Scan a clip-art floral design and print it out. Attach it under the mat so that it peeks out from the top.

4. Attach the small title to the brocade ribbon with eyelets. Adhere the title to the bottom of the floral print piece.

5. Slip the photo into the frame. Adhere the family name to a piece of mat board to keep it sturdy, then attach it to the photo with foam-core dots, adhering the ends with archival glue.

6. Create plaster flowers with a plastic soap mold. Age them with paint. Use wood stain gel dabbed on cotton swabs to get around the curves. Let the paint and gel dry, then attach them to the mat with industrial adhesive. Lay the piece flat for 24 hours to make sure they're firmly attached.

Variations

• A traditional Czech straw doll or Czech ribbons would also have worked well for embellishment.

• I really like the clothes in old photos. The buttons and ribbons on the women's vests could have been echoed by adding similar embellishments to the mat or frame.

Handmade with Love

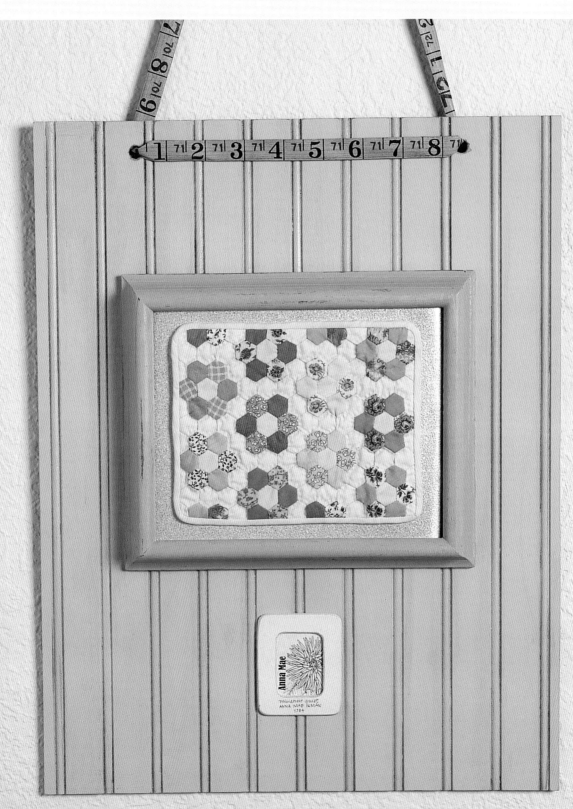

When I was young, my grandmother made this fantastic miniature quilt for my dollhouse. I've always loved the colors and felt it was worthy of framing. I mounted it onto a background of silver metal that reminds me of the metal tumblers she used for serving cool spring water. Her favorite flower was the dahlia, so I used that in her nameplate below the quilt. The antiqued beadboard background adds to the vintage look, and I think the measuring tape is pretty darn cute.

What You Need

16 x 20-inch (40.6 x 50.8-cm) piece of beadboard
Handsaw
Drill
Acrylic paint
Paintbrush
Wood stain
Cheesecloth
Wooden frames, large and small
Sandpaper
Flower illustration or clip art
Solid-colored paper
Scissors
Metal scrap
Industrial adhesive
Miniature quilt, or other small handmade item
Adhesive-backed hook-and-loop tape
Antiqued-look measuring tape
Old spool

What You Do

1. Trim the beadboard to size, or have it cut for you at a home improvement store. Drill two holes at the top for hanging.

2. Paint the beadboard with acrylic paint, then antique it by wiping stain into the grooves with cheesecloth. Paint the wooden frames. Lightly sand the painted surfaces.

3. Scan the flower illustration and print the crafter's name to fit in the small frame.

4. Attach the scrap metal inside the larger frame with industrial adhesive, then adhere the frame to the beadboard, also with industrial adhesive.

5. Attach the quilt or handmade item to the metal with adhesive-backed hook-and-loop tape.

6. Thread the measuring tape through the holes in the top of the beadboard. Add the spool to the top of the nail after hanging.

Variation

• This same idea could be used with baby's shoes or even a favorite piece of handmade clothing.

Sentimental Value

My mom's mom brought this cameo home from a trip to Italy and it has always had sentimental value to me. I decided to incorporate it into a memory piece so that I could see it all the time. I layered the cameo on an oval ornament next to a scanned photo of my granny when she was a child. The rest of the materials evoke the past, including lavender—the flower of remembrance.

What You Need

Old photo

Vellum

Heavy card stock

Cardboard or mat board

Decoupage medium

Spray adhesive or adhesive of your choice

Scissors

Ribbon

Scrapbooking papers

Foam-core dots

Dried lavender

Oval photo holder

Thin-gauge wire

Piece of jewelry

Industrial adhesive

Antiqued silver frame

What You Do

1. Scan and size the photo to fit in the frame. Add the name in the font of your choice and print it out.

2. Print the title on vellum, tearing the edges for a nostalgic look. Back the vellum with a piece of heavy card stock.

3. Decoupage the scrapbooking papers onto cardboard, then adhere the photo to the cardboard. Use a ribbon as a border between the two sections of the layout.

4. Adhere the vellum title over the scrapbooking paper, using foam-core dots. Tear the title a bit and tuck a piece of dried lavender into the opening.

5. Cut and insert a nostalgic piece of scrapbooking paper inside the oval photo holder.

6. Wire your piece of jewelry to the top of the photo holder and add a ribbon.

7. Adhere the photo holder to the display.

Variation

- Consider attaching a much-loved piece of jewelry and photo to the top of a jewelry box.

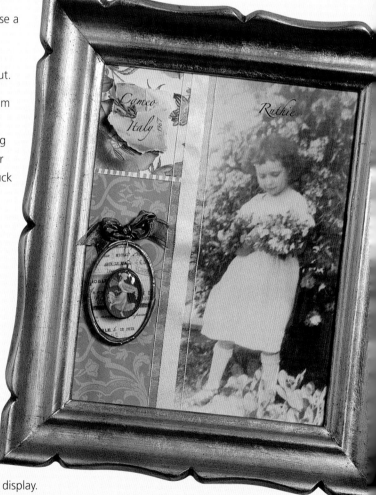

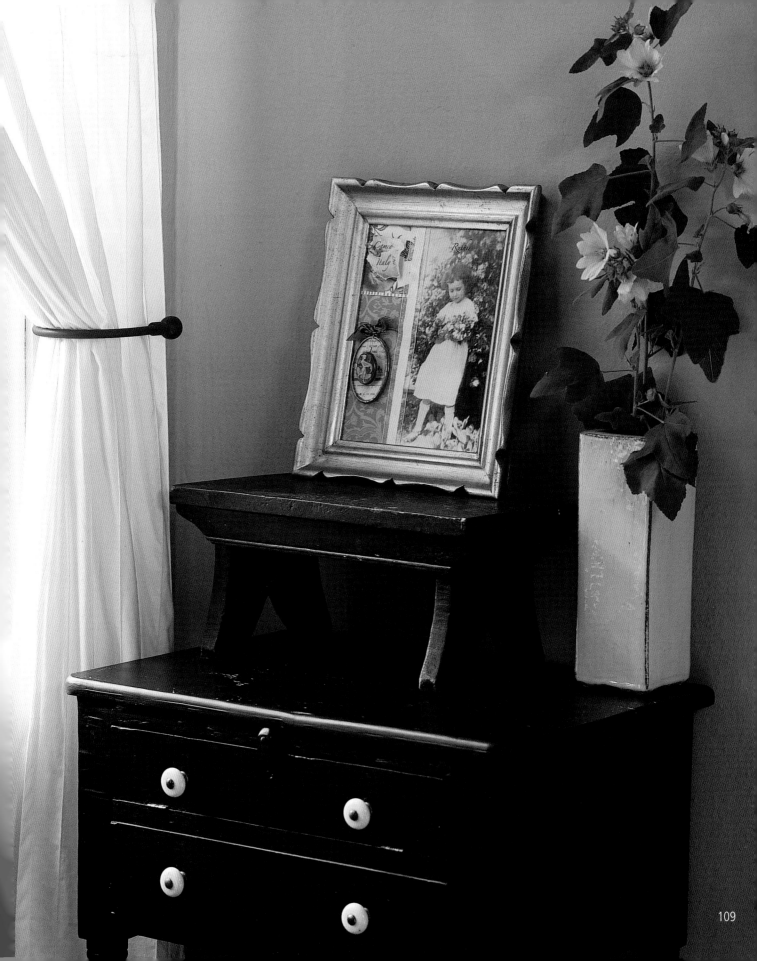

Roots

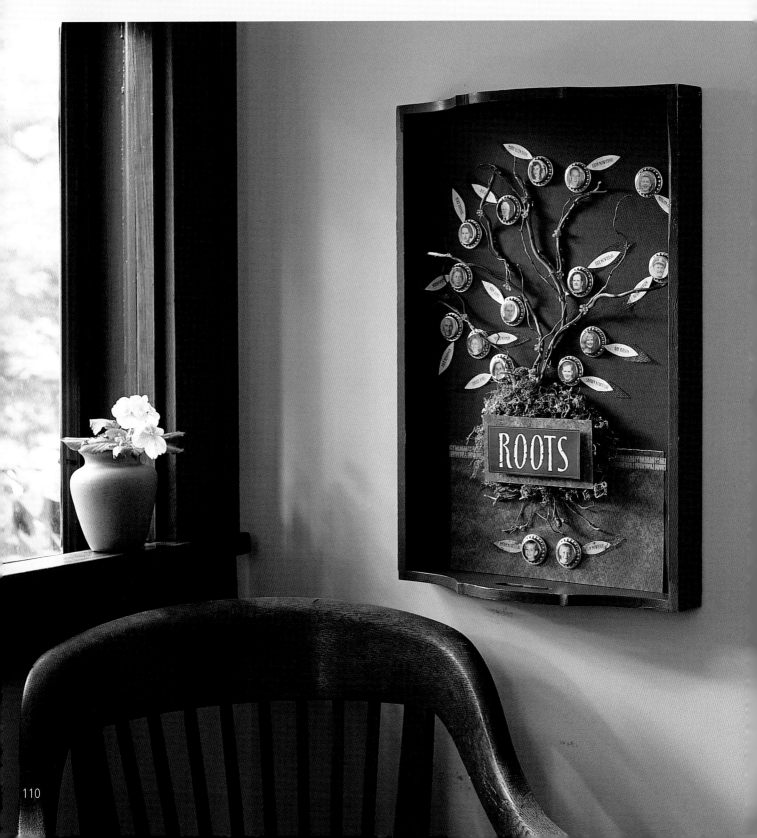

I created this as a decorative and informative way for kids to think about their ancestry. I also wanted it to be gender-neutral. I used an old cinnamon-colored tray and sacrificed an old, curly, willow wreath to make the tree. Metal washers make the background of the flowers, and moss adds texture to the roots.

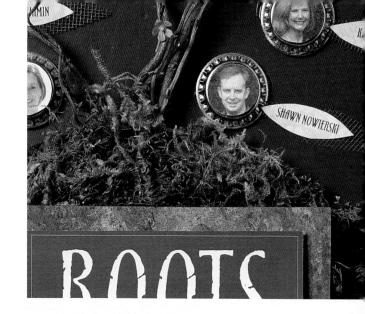

What You Need

Family photos printed on glossy paper
Adhesive-backed vinyl tile
Patterned scrapbooking paper
Scissors
Screen mesh
**Industrial adhesive, or glue gun and
 hot glue**
**Vintage tray (this one is 22 x 15 inches
 [55.9 x 38.1 cm])**
Curly willow or grapevine
Small plastic or silk flowers
Craft moss
Mat board
Card stock
Foam core
Metal washers
Bottle caps

What You Do

1. Scan and crop your photos. Print them in black and white on glossy paper, all the same size.

2. Print out the family names on a light-patterned paper. Trim them into leaf shapes. Cut out larger leaf shapes from screen mesh.

3. Cut and position a piece of scrapbooking paper near the bottom of the tray where the roots will be.

4. Arrange the curly willow into a tree shape, adding little flowers if you like. Secure the position of the branches in place with glue.

5. Add moss to the bottom of the tree, securing it in place with glue. Trim a slate-patterned vinyl tile and adhere it on top of the moss. Then print out the word "roots" on a piece of card stock, back it with foam core, and attach the piece on top of the mat board.

6. Adhere the mesh leaves to the tray, then add the name leaves on top of them. At the end of each leaf, use industrial adhesive to add a washer and a bottle cap. Adhere the pictures on top of the bottle caps.

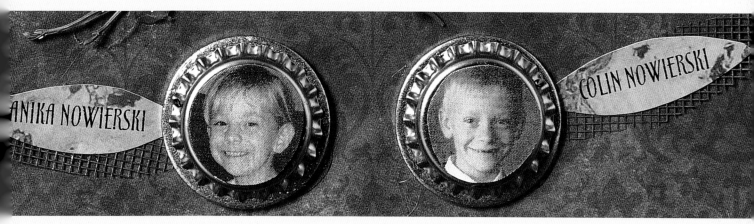

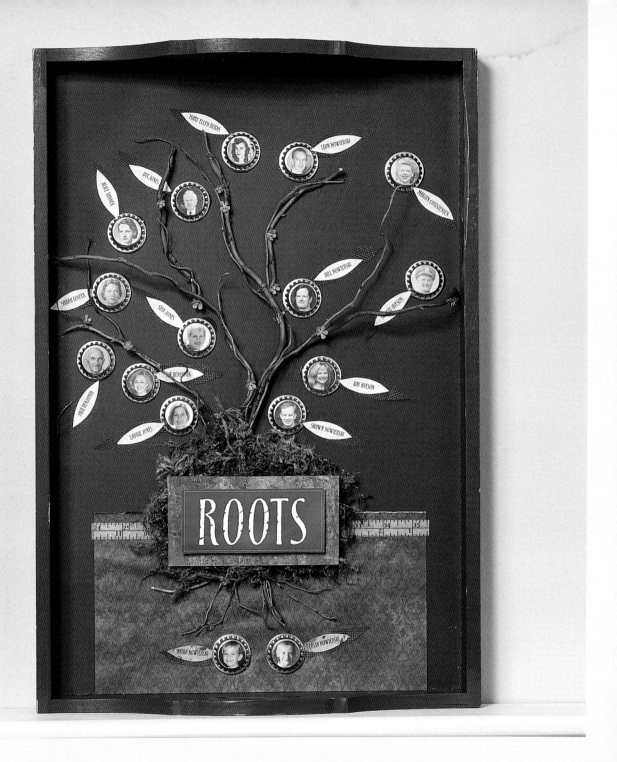

Variations

- Consider dried leaves as a background, or use green, silk leaves for a lush look. The faces could also be on birds (in nests?) or koala bears (or monkeys!) climbing a tree.

- A family tree could translate into a mural for a nursery. Paint the tree on the wall and hang oval portraits from the branches. Or paint an under-layer with magnetic paint, and use magnetic frames and letters on the finished mural for the family portraits.

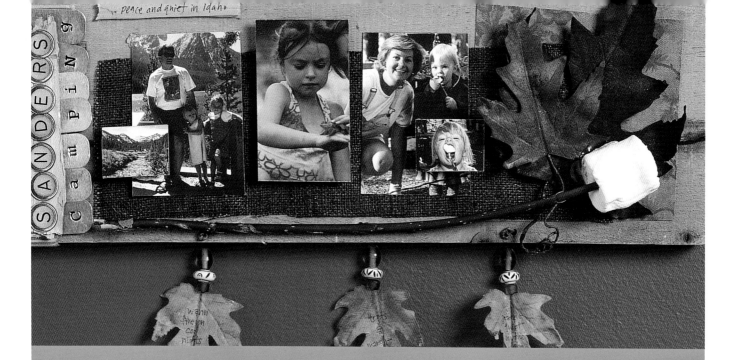

Destinations

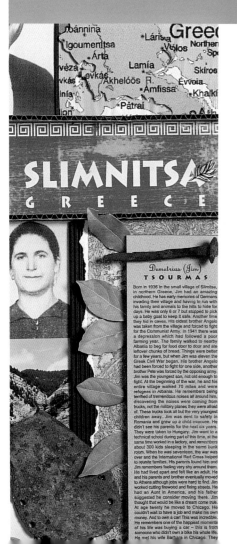

Some of the most memorable moments happen when we leave behind the familiar routine and discover new places. Chances are you'll come back from your travels with loads of wonderful photos that just call out to be displayed. In this section, you'll find some imaginative ideas for showcasing your vacation memories. Create a collage with maps and photos from a trip and show it off on an easel. Incorporate elements that evoke the spirit of your trip—a marshmallow for a camping trip layout, or shells from a beautiful beach honeymoon. Making these projects will bring back all the fun you had on your getaway and help you remember it even when you're back to the daily grind.

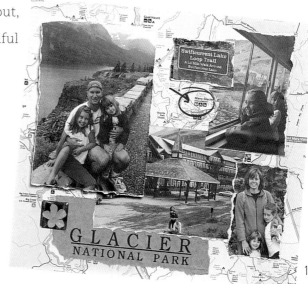

Honeymoon in Paradise

An amazing honeymoon in Fiji—a beautiful, secluded setting, the honeymooner's names carved in a stepping stone, the overweight suitcases full of shells—those are some of the moments captured on this rustic tray. I used photocopies of a hotel brochure, the couple's own photos, and, of course, shells. I like the torn edges of the photos in this project. I also love that this tray could go on the wall or on a tabletop easel for display.

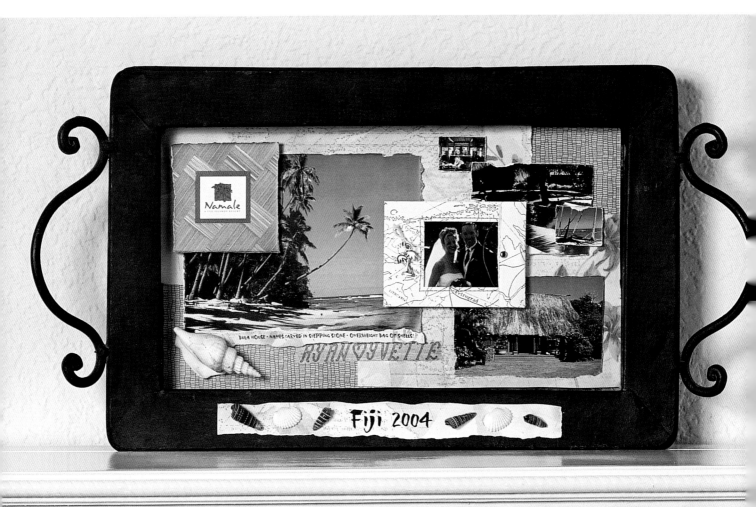

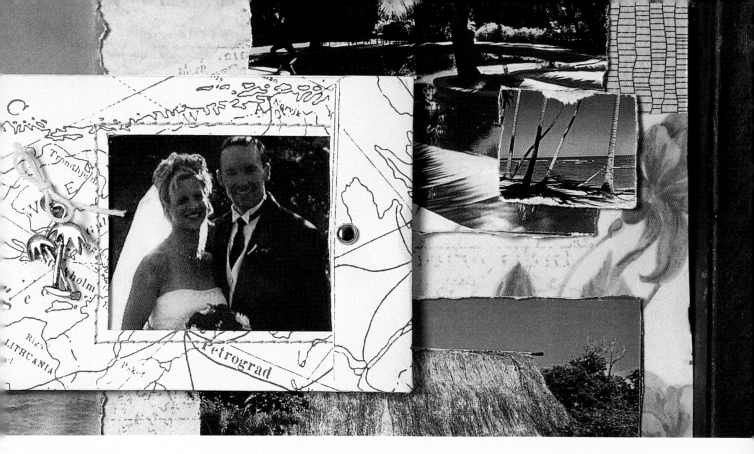

What You Need

9 x 14-inch (23 x 36 cm) antiqued tray
Scrapbooking papers in various patterns
Map of honeymoon location
Spray adhesive or adhesive or your choice
Photos from vacation-resort brochures
Decoupage medium
Card stock
Foam core
Scrapbooking "view" envelope
Wedding photo
Palm-tree charm
String
Mat board
Shells
Industrial adhesive

What You Do

1. Start by tearing the papers and map, arranging them inside the tray in the design of your choice. Fold the paper first for the cleanest tear. When you're happy with the design, adhere the pieces to the bottom of the tray.

2. Photocopy vacation photos. Arrange and adhere them over the layer you just completed.

3. Print the couple's names and decoupage it to the layout (I used a photocopy of a photo of a carving of their names). Print and tear a line of text about memorable moments. Tear the edges of the paper and mount the piece on card stock before adhering it to the layout.

4. Add a piece of foam core to the back of the envelope. Slip a wedding picture into the envelope, and attach the foam core to the layout. Attach the palm-tree charm to the envelope, and tie it with a little piece of string.

5. Cut out the resort's logo, tear the edges, and attach it to foam core, then position it on the layout.

6. Print out a title, tear the edges, then attach it to a piece of mat board, and attach the mat board to the tray. Adhere the shells on top of the title with industrial adhesive.

Variations

• Use a tray fitted with protective glass.

• Consider decoupaging photos and cropped brochures under a glass-topped table.

Arrivederci Roma

Before I was a graphic designer, I was an architect. While in college I spent a summer in Rome, and it changed the way I looked at the world as a designer. This project was created digitally, so it was easy to include scanned images: a postcard of the piazza I called home, a photo of a piazza I studied, a watercolor from my sketchbook. While in Rome, I also obsessed in my sketchbook about my future "nest"— the apartment I would find when I returned to the U.S.

What You Need

9 x 11-inch (23 x 28 cm) hanging display frame
Scanned photos and illustrations
Scissors
Scrapbooking stickers (calendar months and postage meter image)
Spray adhesive

What You Do

1. Scan the images (photos, postcard, sketch, illustration, postage meter image) and arrange them as you like.

2. Make a color print of the arrangement and trim the edge in a gentle curve.

3. Add stickers near the edge.

4. Attach the piece to the display frame with spray adhesive.

Variations

• Postcards, souvenirs, brochures, maps—anything you can scan can be used in your layout. Crop it tightly or enlarge it for emphasis.

• Originally I was going to frame this in a traditional frame with black and white photocopies of The Nolli Plan (an illustration of the city of Rome from 1748). I still think that would have been beautiful, but I like the idea of this more modern frame contrasting with the history I learned of Rome.

rome
SUMMER ABROAD 1991

My father-in-law is a wonderful man with an amazing life story. He grew up in a little village in Greece and was a child evacuee in the Greek Civil War. His story, depicted here, is complemented by photos of him and his parents, and more recent photos from a later visit. Found objects I gathered from the village are added, along with a Greek coin showing his village on the map. The little bay leaves softened up the hard edges and made me think of the laurel wreaths worn by ancient Greeks.

What You Need

12 x 22-inch (30.5 x 55.9 cm) frame
Scrapbooking papers
Photos
Map of the area
Spray adhesive
Foam-core dots
Cardboard
Found objects
Local coin
Bay leaves (optional)
Industrial adhesive

What You Do

1. Print the title. I added a Greek-key border design, but you could adapt this for any motif that fits your family heritage.

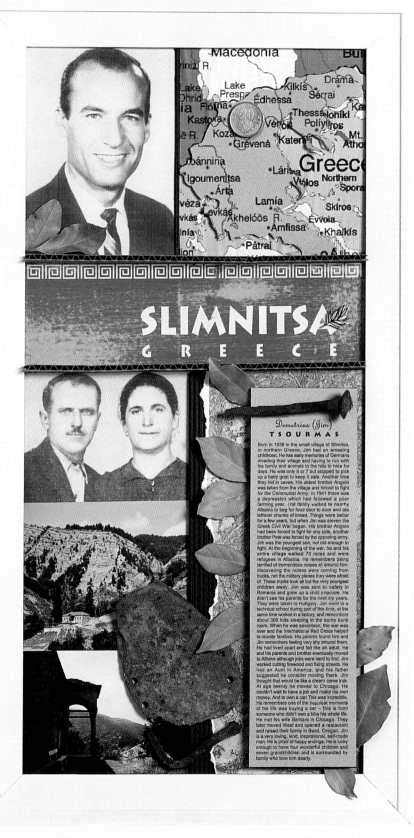

2. Adhere the photos, title, and map to the layout.

3. Print a second copy of the map on a different paper, cut out the shape, and adhere it on top of the first map with foam-core dots.

4. Adhere pieces of corrugated cardboard between different layout elements to serve as borders. Put down a layer of corrugated cardboard to serve as the background for your journaling piece. Layer scrap-booking paper on top of the cardboard background.

5. Print the journaling story and attach the foam core dots, then position it over the background you just created.

6. Adhere the found objects, coin, and leaves (if using) with industrial adhesive over the layout.

Happy Campers

Photos from a camping trip call out for a rustic treatment with natural elements. I mounted all the pieces on a label board from an old wooden crate, but any piece of distressed wood will do. I love the marshmallow on a stick. This project captures the spirit of fun in the great outdoors.

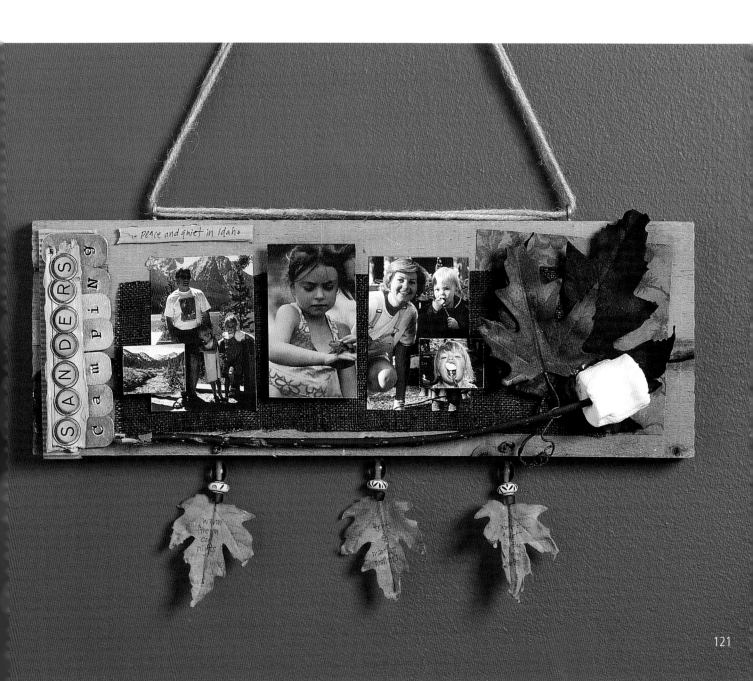

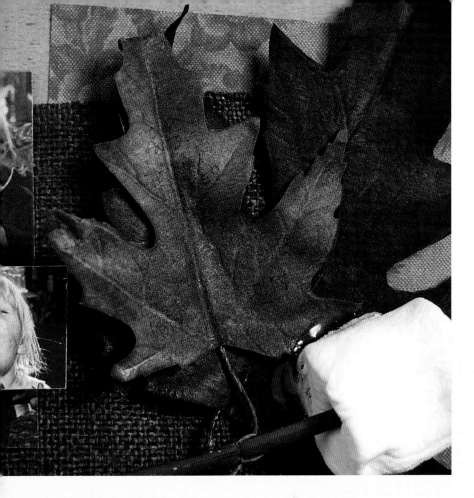

What You Need

Wooden crate label board

Drill

Piece of burlap or "fabric paper"

Scrapbooking paper

Photos

Craft glue

Foam-core dots

**Scrapbooking sticker letters and
 metal tag letters**

Corrugated cardboard

Glue gun and hot glue

Scrapbooking leaves, real or faux

Bits of bark

Marshmallow on a twig

Beads

Strong wire

Jewelry pliers

Twine for hanging

Eye screws

What You Do

1. Drill three holes for the leaves on
the bottom of your piece of wood. Drill
two holes on the top of the piece for
the eye screws you'll use as hanging
hardware.

2. Attach burlap, papers, and photos
to the display. I added foam-core dots
behind some of the photos for height. I
also wrote on a piece of scrap wood
and attached it to the frame. Attach
metal letter tags to corrugated
cardboard, then add stickers to spell out
the family name on a piece of scrap
wood. Adhere the piece of wood on
top of the metal tags, and attach the
whole piece to the wood background
with hot glue.

3. Write memories from the trip on the
faux leaves. Add the leaves to the crate

piece with hot glue. Spear the marsh-
mallow on the twig, and attach it to the
crate piece with hot glue.

4. Write more memories on additional
leaves and attach beads to the leaves
with heavy wire. Add wire to the tops
of the leaves, then bend the wire
through the holes you drilled on the
bottom of the wooden background.
Close each wire loop with jewelry pliers
to secure it.

5. Screw in the eye screws on the top
of the wood piece, and string the twine
through them to hang the piece.

Variations

• Consider using burnt paper.

• Incorporate can lids, found pinecones,
wrappers—pack it in, pack it out, and
glue it on.

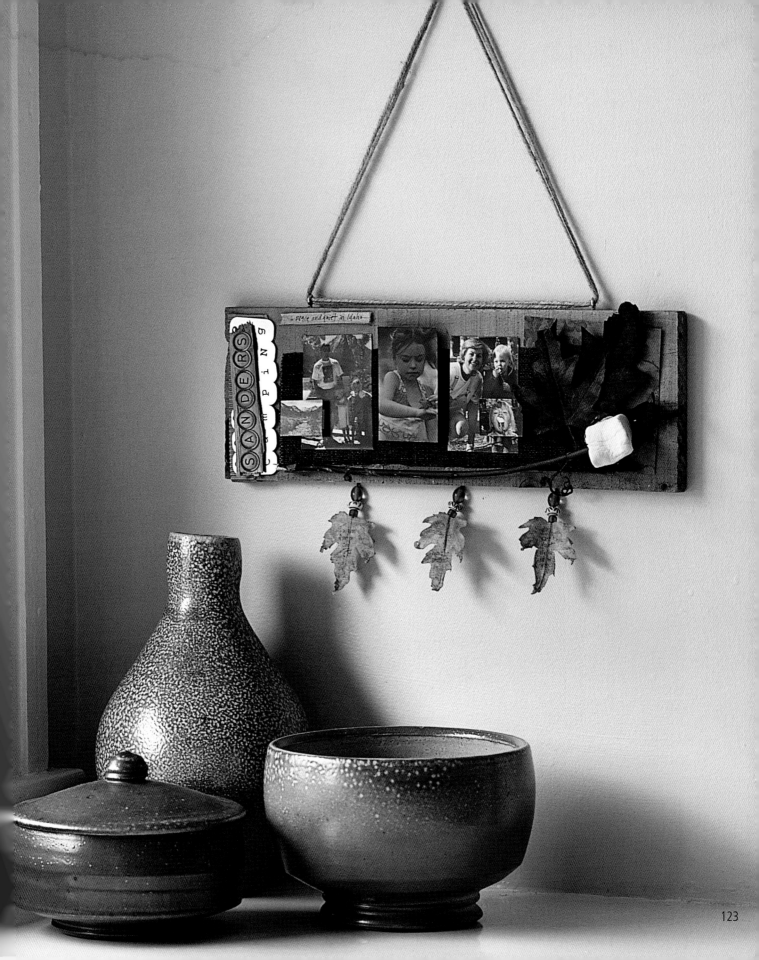

Scenic Beauty

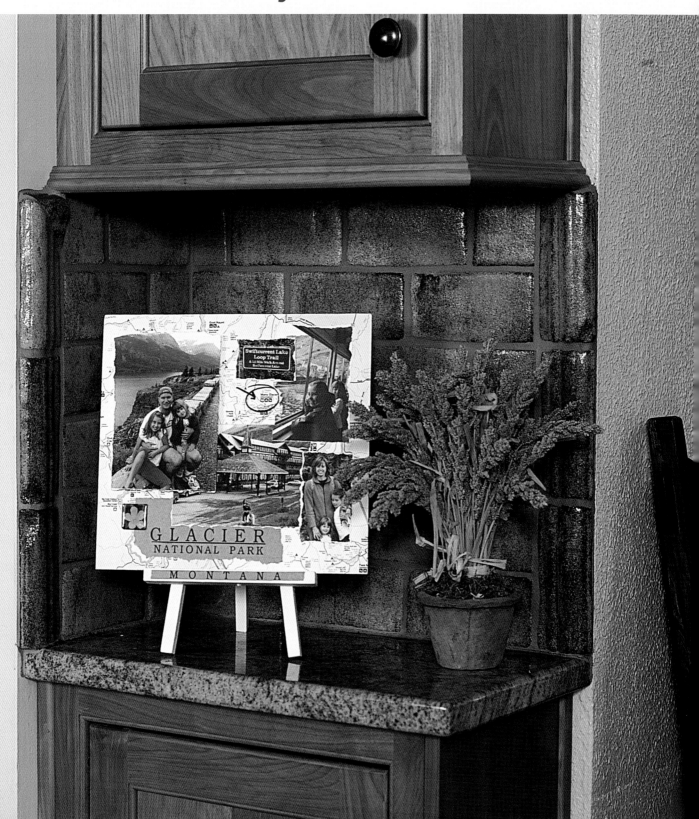

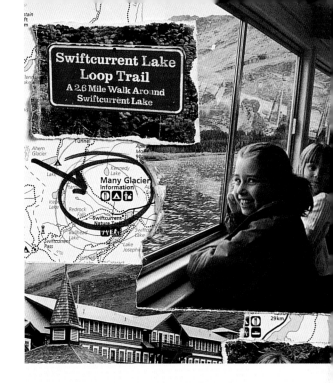

Here's a simple and inexpensive way to show your vacation photos in an artistic way. I started with a map of the park, then layered torn photocopied photos. I also tore bits from a gift bag for the title on the foam-core piece and the easel. The sweet little yellow wildflower photo was taken by seven-year-old Kate. Note the torn edges and sloppy circle on the map, bringing attention to the spot where we stayed, the spectacular Many Glacier Hotel.

What You Need

Foam core

Spray adhesive

Map

Craft knife

Marker

Torn photos

Gift bag

Wooden easel (painted white)

Industrial adhesive

Card stock

Cardboard

Clear sticker

What You Do

1. Spray mount the map to the foam core. Trim around the edges with a craft knife. Circle your vacation spot on the map with a black marker.

2. Tear the gift bag titles and spray mount them to the map and easel.

3. Color copy photos and tear the edges. Arrange and adhere them to the foam core with spray adhesive. Peel back part of a photo around the circled location on the map.

4. Back your spotlight photo with card stock and cardboard for strength and dimension. Adhere the piece to the background with industrial adhesive.

5. Add a clear sticker to a special photo (the wildflower photo in this case) and adhere it to the background.

Variations

• Use a foam core and easel combination for a quick, inexpensive display. It's very lightweight and would be inexpensive to ship as a gift.

• This makes a great desktop project. The subject could be pets, children, hobbies, school photos, or just about anything.

• Cover the whole easel with a spray-mounted or decoupaged map for a fun look.

Acknowledgments

Thank you to Lark Books and Joanne O'Sullivan for the creative freedom you've allowed me, and thank you to everyone who gave me subject material for this book—without really knowing what I was doing with it! A big thanks to my wonderful, thoughtful husband John for his patience and encouragement and for the embarrassment he causes by bragging to strangers about me. (Maybe I do sorta like it.) I am so lucky to have you. Thank you to my amazing dad who can make anything (and does so without complaint) and a million thank yous to my dear mom, my biggest fan and the brightest light in my life.

About the Author

Stephanie Inman is a graphic designer and lettering artist. She has been a "master calligrapher" since age 14 and received her Bachelor of Architecture from the University of Oregon. It is this varied background of designing buildings and rooms, logos and brochures, along with a lifelong emphasis on lettering, that gives her a unique perspective on design. Stephanie lives in Boise, Idaho with her husband John and two daughters, Kate and Amy. She enjoys chocolate, volleyball, skiing, and painting rooms.

Index

ML

9/06